5 Feb 2012

Ten Photo Assignments

edition espresso

Amanda Quintenz-Fiedler (amanda@amandaquintenz.com)

Editor: Gerhard Rossbach
Copyeditor: Jocelyn Howell
Layout and Type: Petra Strauch
Cover Design: Anna Diechtierow
Printer: Tallinna Raamatutrükikoja OÜ
Printed in Estonia

ISBN 978-1-933952-79-6

1st Edition 2011
© 2011 by Amanda Quintenz-Fiedler

Rocky Nook Inc.
802 East Cota St., 3rd Floor
Santa Barbara, CA 93103

www.rockynook.com

Library of Congress Cataloging-in-Publication Data

Quintenz-Fiedler, Amanda.
 Ten photo assignments : to develop your photographic skills / Amanda Quintenz-Fiedler. -- 1st ed.
 p. cm.
 ISBN 978-1-933952-79-6 (pbk.)
 1. Photography--Problems, exercises, etc. 2. Photography--Technique. I. Title.
 TR162.Q85 2011
 771--dc23

 2011023008

Distributed by O'Reilly Media
1005 Gravenstein Highway North
Sebastopol, CA 95472

rockynook

Amanda Quintenz-Fiedler

Ten Photo Assignments

to develop your photographic skills

WITH PHOTOS BY
Bobby Sanchez
Chuck Place
Dan O'Day
Glenn Rand
Jesse Strigler
Judith Preston
Kevin Osborn
Mercury Megaloudis
Michael Penn
Randy Sullivan
Robert Bradshaw
Sam Rivera
Steve Dutcheshen
Tom Flory

edition espresso

Contents

While many of the images in this book illustrate a specific concept or portion of an assignment, others are included simply to inspire you. A variety of photographers have contributed stunning images that we hope will motivate you to get out there and start shooting!

Introduction

We've all had moments when we saw the perfect photograph and weren't able to capture it: the look of surprise on a child's face when they open the perfect present, the unexpected instant when the groom dips the bride for a hero's kiss, or that thrilling apex of a motocross jump when an athlete's legs stick out behind him as his bike seems to hang suspended in the air. These are moments you can never get back; the second they happen, they're over—unless you have the presence of mind, training, experience, and know-how to snap that frame perfectly when it counts.

In some circumstances, you may have time to fiddle with dials, evaluate the histogram, and try to recreate the shot you want, but the purpose of this book is to help you gather the tools you need to get it right the first time, every time, and always get the shot.

This book will turn you into a better photographer by leading you through a series of practical assignments that will help you better understand the capabilities and limitations of your equipment, the theories and practices of a good photographer, and how you can see the scene in front of you and ensure that you get the perfect shot. Each of the five sections in this book has two assignments to help you learn by doing.

Don't get me wrong—reading this book won't be some quick fix for a couple of issues you have. This is a book about doing. You have to work your way through each of these assignments, be honest with yourself about whether or not you understand them, and determine when you are ready to move on.

In order to get the most out of this book, you also need to have proper equipment to get a full understanding of the processes, techniques, and controls that you are able to employ as a photographer who knows what you're doing. This means that you must have a manually adjustable camera—preferably a digital SLR with interchangeable lenses and fully manual controls for aperture, shutter speed, and focus. You can still get a lot out of this book with a point-and-shoot camera (one that has an attached zoom lens), but it must have a manual operation mode that allows you to change the aperture and shutter speed; otherwise, you cannot apply the knowledge in these pages to the exercises.

If you want to be a better photographer who is in control of your images, you have to make the decisions; you can't let your camera do it for you. If you don't have a manually adjustable camera, this book won't be very helpful, so either go out and get one now to take the next step, or wait until you're able to get one to proceed with these assignments.

If you are ready to work toward becoming a better photographer, follow these simple guidelines and you will quickly see yourself evolving as an image-maker:

1. Do the work! – If you don't work your way through each individual assignment, you are only letting yourself down. You can't learn these skills without applying yourself at every stage along the way.

2. Do the assignments in order! – This book is designed to build on concepts from one stage to the next. The more carefully you follow the layout of this book, the more you will be able to apply what you have learned to expand your knowledge base.

3. Be thorough! – Sometimes these assignments might seem like overkill, but trust me, when you repeat a process or look at it from a different perspective, you will solidify your knowledge. Don't shortcut your success.

4. Be honest with yourself! – Sometimes the best way to learn something is to do it again. And again. If your results don't seem to match the examples provided, try to figure out where you went wrong and do the assignment again if need be. You are only hurting yourself if you skimp in this process.

If you want to be the best photographer you can be, you have a lot of work ahead of you. But even though this process might be difficult at times, it should also be fun and rewarding. At the end of the day, you are going to see a difference in your photography. So what are we waiting for? Let's get started.

Section A
You're Smarter Than Your Equipment

Septa R8 © Michael Penn. Courtesy of the artist.

Your knowledge, experience, and skills will be your most important equipment to make a great image. In fact, the first thing you should do when you get a camera (or now that you are reading this, go back and do) is read the manual. Even though the information discussed here will help you refine, clarify, and even circumvent some of the standard functions of your camera, you should understand those functions before trying to bypass them. At this point, I will assume that you have a good working knowledge of your specific camera.

As you grow and learn throughout these exercises, you may find that you are limited by your photographic equipment and its inherent short-comings. Anything mass-produced may not be perfectly calibrated out of the box. What's nice about higher-level cameras is that often you have the ability to either manually adjust the equipment itself or perform tests on the equipment to be sure you know what is really happening.

In the two assignments in this section, we are going to evaluate the way your camera handles light and review the basic functions of your lenses to make sure we are starting with a good solid base to build from, both in terms of equipment and knowledge. From this point forward, keep track of how your camera and your equipment solve the problems addressed within these assignments. Each camera and meter combination will react differently, so you are taking the first step toward becoming a better photographer by ensuring that you know everything about your specific equipment. If you get a new lens, test it. If you get a new camera body, definitely test it. The more you understand about your tools, the better choices you can make later.

In the introduction, I mentioned that you will need to have a camera that is fully manual to get the most out of this book. Every modern camera has a built-in light meter that will help you find the proper exposure for a scene based on the amount of light in the scene. In later sections, we will discuss how to determine when we should use different types of metering, such as center-weighted, averaging, or spot metering.

Modern cameras also have a quantifiable light sensitivity setting; this is known as the camera's ISO. This quantity can be set in a digital camera, but it isn't always 100 % accurate. The ISO setting will be approximately equal to the actual sensitivity of your particular CCD or CMOS chip, but the actual exact sensitivity, or the Exposure Index (EI), of your chip might be slightly more or less. In this book, we aren't interested in close; we only want precise. What good will an exact exposure reading be if the camera itself is not reading the light accurately? If you could be certain that your exposure was going to be exactly what you planned it to be, even if your internal sensors or ISO settings were incorrect, wouldn't you take advantage of that ability? Well, we can; so grab your camera and read on.

© Kevin Osborn. Courtesy of the artist.

What Will You Need?

For this assignment, you will need the equipment that you intend to use throughout this book. If at any time you upgrade your equipment, drop your meter in the pool, loan your camera to your unreliable cousin, or just want to ensure that you have the right info, come back to this assignment. This process is not terribly difficult, and it will help you sleep better before (and after) a really big photo shoot, because you won't have to question whether you got "the shot" or not.

What I Recommend

⊕ Your fully manually adjustable camera
⊕ A tripod

- A handheld light meter
- A manufactured digital gray card
- A Zebra card with black, white, and 18 % middle-gray tonalities
- A model in a textured white shirt
- A sunny day (if possible) with a dark, even background
- A notebook and pencil
- A computer
- Photo management software to open files and evaluate exposures

Purpose

The purpose of this assignment is to establish a baseline for how truthfully your camera records light. Your exposure setting may indicate that you have set your ISO to 100, but your camera might actually be reading at 80 or even 60. This assignment will also balance the readings of your in-camera or handheld meter with the settings of your camera. That way, if your meter or camera is slightly off, you will be able to specify the compensation that results in a perfect exposure. Once you have completed this calibration (the assignment), you can trust that your camera and meter will work together harmoniously from this point forward. If they are both perfect, fantastic—this assignment will prove it. If not, you will have the ammunition you need to work around any shortcomings.

Procedure

1. Set Up – Let's make sure that we are starting in the same place. You should set your camera up on a tripod for ease of use (though this is not necessary if you don't have one). Place your model, in a white shirt, into a scene fully illuminated by the sun (the sun should be behind both you and the camera). Have your model hold the gray card and the black, white, and gray strip perpendicular to your lens. The model and the cards should be illuminated by the same light. In other words, make sure that both the model and the cards are in direct sunlight, not in shadow or under cloud cover. (Your model needs to hold the gray card steady. If you are worried that they won't, use the light stand and tape the card to it.)

2. When placing your camera, you want to be sure to use a close crop. The gray card should take up a good portion of the image so that you can see it and take appropriate readings in your photo software. [⬅ 1.1]

1.1 This is the type of set up we are looking for. Something simple with all of the required elements. To create this scene, I put my husband, Steve, in a white shirt and asked him to hold a DGC-150 Digital Gray Card and a QP Card so I could capture the middle gray tonalities as well as white, gray, and black. You can use any manufactured middle gray card for this book.

3. Initial Camera Settings – Set the white balance on your camera to "sunlight." We will discuss white balancing in more detail later, but for now, trust that the sunny symbol on your white balance menu is correct for this scene. Set your camera ISO to 100.

4. Set your handheld incident light meter ISO to 100 as well. This way, we are comparing apples to apples.

5. Read the incident light (the light falling on the subject) by pointing the diffusion dome of the meter toward the light source–in this case, the sun. Write down the exposure information for aperture (f-number) and time (shutter speed). (To get the most out of this book, I highly recommend investing in an incident light meter. However, if you don't have an incident light meter, you can use the meter in your camera. Fill the frame with your gray card and use the camera's meter settings as your starting point. Make sure the camera does not cast a shadow on the card.) [⊡ 1.2]

6. Set your camera with the exposure information that you just wrote down; for my reading, it was f/16 @ ¹⁄₁₂₅ sec.

7. Open up the aperture two stops from the meter reading. "Open up" means that you need to increase the amount of light that is hitting the sensor by making the aperture opening larger (hence, "open up"). This can also be accomplished by slowing down the shutter speed. Although either will work for the purposes of EI testing, let's just use the aperture for this exercise to make things simpler. So, since my starting aperture was f/16, my new aperture should be f/8.

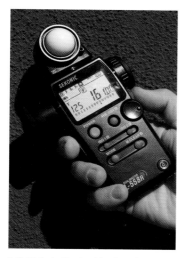

1.2 This is the incident meter that I use: the Sekonic L-558R. It has both incident and reflective metering capabilities, and lots of functionality.

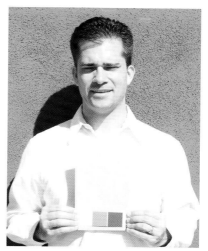

1.3 This is what we expect to see with the first shot. It should be overexposed (too light), meaning there shouldn't be much detail in the whites. We go to this extreme to ensure that we are getting a full range of exposures, from over to under, so that we can find the perfect match for our camera system.

8. Take your first photo with this adjusted exposure setting. [⊡ 1.3]

9. Close down your aperture ⅓ stop (or ½ stop, depending on the smallest aperture shift you can make with your lens) and take another shot.

10. Do this again for every aperture between two stops over and two stops under your metered exposure (this means I should take shots from f/8 through to f/32). If your lens won't open up any further, change the shutter speed by ⅓ or ½ stop instead so that you get a full range of images. Once you have taken these shots, you are done with the "on location" portion of this assignment, so you can pack up your equipment and head to your computer.

11. Download your images, but don't change anything! This is not the time to play around with your exposures—we are doing careful work here! [⊡ 1.4]

12. In your photo management software, arrange your image files in order from most exposed to least exposed, keeping track of which image is which. [⊡ 1.5]

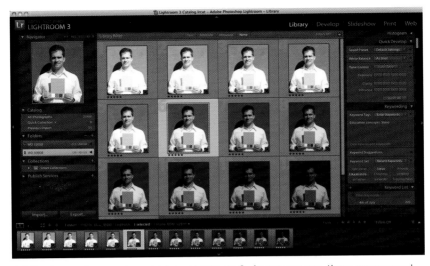

1.4 To view my images, I used Adobe Lightroom 3. As you can see, these are arranged from most exposed to least, in the same order I took them on location. If you followed the procedure correctly, you should end up with 13 images (for a ⅓ stop camera).

13. In your photo software (Adobe Photoshop or something similar), find the file for which the RGB values of the white card are closest to 245, 245, 245. To do this, open each file and hover your cursor over the white area of your test card. Your RGB values are the red, green, and blue values for that spot, which can usually be found in an information block at the side of the image. The image with the 245, 245, 245 RGB values has the most accurate EI. [1.6]

14. Be sure there is not any clipping in the frame and that you can see the texture on your subject's shirt. (Clipping occurs when you overexpose or underexpose your subject, leaving no detail in the extreme highlights or shadows. You can use the histogram to see if there is clipping in the frame. In a program like Adobe Photoshop, you can enable a histogram function called "Show Clipping Warning" to indicate clipped areas.) Use the closest RGB values that don't cause clipping in the final image.

15. Determine how many ⅓ or ½ stops there are between this image and the first image. That number of stops is how "off" your camera/meter combination is, so the new EI for your camera will be ISO 100 +/− those stops.

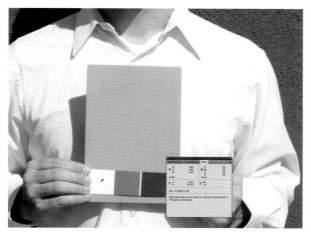

1.5 To review the white tonalities in each of my images, I used Adobe Photoshop CS5. Here, you can see that the RGB values are 244, 244, and 246, which is pretty close to the 245, 245, 245 we are looking for.

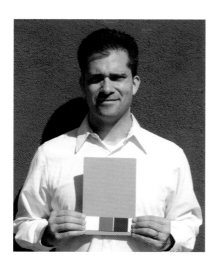

1.6 This is the full image at the correct exposure as determined using the Eyedropper Tool in Adobe Photoshop. You can see a range of tonalities from the textured white shirt to details in the shadowed side of my subject's face and hair, and in the shadow behind him. This exposure will give my images the greatest depth without causing any information in the highlights to be lost.

	COMPENSATION	EXPOSURE INFORMATION	EI	RGB VALUES (R, G, B)
Image #1	+2	f/8 @ $\frac{1}{125}$ sec	25	255, 255, 255
Image #2	+1 ⅔	f/9 @ $\frac{1}{125}$ sec	32	255, 255, 255
Image #3	+1 ⅓	f/10 @ $\frac{1}{125}$ sec	40	255, 255, 255
Image #4	+1	f/11 @ $\frac{1}{125}$ sec	50	255, 255, 255
Image #5	+⅔	f/13 @ $\frac{1}{125}$ sec	60	255, 255, 255
Image #6	+⅓	f/14 @ $\frac{1}{125}$ sec	80	244, 244, 246
Image #7	Meter Reading	f/16 @ $\frac{1}{125}$ sec	100	228, 237, 220
Image #8	−⅓	f/18 @ $\frac{1}{125}$ sec	125	214, 213, 217
Image #9	−⅔	f/20 @ $\frac{1}{125}$ sec	160	205, 203, 208
Image #10	−1	f/22 @ $\frac{1}{125}$ sec	200	190, 189, 194
Image #11	−1 ⅓	f/25 @ $\frac{1}{125}$ sec	250	168, 166, 172
Image #12	−1 ⅔	f/29 @ $\frac{1}{125}$ sec	320	147, 145, 151
Image #13	−2	f/32 @ $\frac{1}{125}$ sec	400	132, 130, 135

1.7 This table shows you the compensation for each image and the final EI associated with the correct RGB values. To show you what your ultimate data should look like, I have included the RGB values for each of my exposures in the last column, but, of course, your values will be different. Use your values to choose the correct EI. Based on this test, the correct EI for my sensor with this camera and meter is actually EI 80, not EI 100.

16. Write down the new EI for your camera based on the table provided. From this point forward, when your meter is set to ISO 100, your camera EI should be set to this new value. For example, I will use EI 80 instead of EI 100. With some cameras and meters, you can manually set the EI to adjust up to two stops in either direction. If this is the case, you can change the setting now and be certain that your system will be calibrated in the future. If not, just know that your camera is different from your meter by this specific value, no matter what ISO value you're using.

Note: You can perform this exercise with your in-camera meter; just be sure to fill the frame with the black, white, and gray cards to get a perfect reading. If your camera has a spot meter, repeat the procedure above, but set your spot meter so that it lands directly on, and is filled by, the gray card. You will still get an accurate reading from your in-camera reflective meter, and will be able to precisely calibrate that meter in relationship to your camera's listed ISO.

Congratulations on completing your first assignment!

Now that we know for certain how precise our exposures are going to be, we can (or must) evaluate the rest of our equipment so that we will have confidence in our choices when setting up a photograph, planning a trip, or preparing for a big job.

© Kevin Osborn. Courtesy of the artist.

What Will You Need?

For this assignment, you will continue using the same equipment you intend to use for the rest of your photography. I know that sounds redundant or obvious, but it is important that you get to know your specific equipment. No two cameras are the same, even if they are the same model from the same manufacturer. In this assignment, we are going to look at interchangeable lenses and see what all the fuss is about.

What I Recommend

⊕ Your calibrated manually adjustable camera and handheld light meter
⊕ All of your interchangeable lenses
⊕ A tripod
⊕ A notebook and pencil
⊕ A computer

Purpose

The purpose of this assignment is to give you an opportunity to work with all of your lenses and understand what each one does and why. Your lenses don't just provide you with a wide-angle view or a telephoto crop—they allow you to control how you see the scene in front of you, through perspective, depth of field, and the speed of the glass in the lens. This assignment is easy to perform, but the real lesson here is in evaluating your images after you've taken them and really looking at the differences resulting from your choice of lens.

Procedure

1. Set Up – Find an interesting scene with a wide field of view and details that you can zoom in on—preferably outside so that there is something in the distance to focus on. Mount your camera on the tripod.

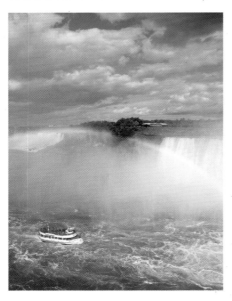

2.1 I had an opportunity to go to Niagara Falls for a wedding. It was the perfect open setting with lots of interesting details to focus in on. When choosing your setting, make sure that there is something far away so that you can zoom in and really see the power of your lenses.

2. Line up your lenses in order of widest angle (shortest focal length; i.e., the smallest millimeter lens; for instance, 17mm) to most telephoto (longest focal length). If you have a zoom lens, you will be taking several images at different focal lengths, so you can incorporate this lens where you see fit.

3. Take a meter reading. You have gone to the trouble of calibrating your meter and camera ISO, so use those tools to determine the perfect exposure and set your camera accordingly.

4. With your widest lens in place, focus on a detail in the distance that is easy to spot and reuse, and take your first image. [⬕ 2.2]

2.2 I shot this image with my zoom lens that expands between 17mm and 50mm. This shot was taken with the lens set at 17mm.

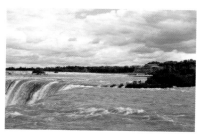

2.3 This image was shot with the same zoom lens, but this time I zoomed the lens to approximately half its length and shot the image at 36mm.

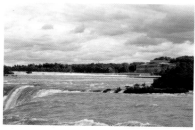

2.4 This is the final image shot with my zoom lens, with the zoom fully extended at 50mm.

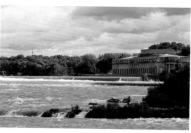

2.5 This image was shot with a 105mm fixed focal length lens.

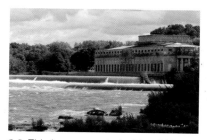

2.6 This image was shot with a 200mm fixed focal length lens.

2.7 This image was shot with a 300mm fixed focal length lens.

5. Change to your next (longer) lens and focus on the same detail. Repeat this process until you have taken an image with each lens focused on the detail in the distance. Make sure you maintain the same exposure! If your lenses have different aperture settings, take another meter

reading and use that data. Also be sure to focus carefully so that you can compare appropriate data at the end of the assignment. If you have a zoom lens, take one image at the closest focal length, one at the mid-range focal length, and one at the furthest focal length. [🔲 2.3– 2.7]

6. Import the images into your photo management software—e.g., Adobe Lightroom or Adobe Bridge. Either of these programs will show you not only the exposure data for each image, but the focal length as well. Use this data to arrange your images in order of focal length (though this should be easy to do based on how close your distant detail appears to be).

2.8 This is the full view of the Adobe Lightroom 3 setup for this particular image.

2.9 This is the image capture information in the same Adobe Lightroom 3 view. If you used a zoom lens, this block of information will give you an accurate lens length for the zoom distance you used.

Dimensions	4256 x 2848
Exposure	$^1/_{60}$ sec at f / 16
Focal Length	105 mm
ISO Speed Rating	ISO 100
Flash	Did not fire
Make	FUJIFILM
Model	FinePix S5Pro
Lens	105.0 mm f/2.8

7. Now comes the hard part. Evaluate all of your images according to the following criteria. I earnestly suggest that you use a notebook to write down your answers for future reference.

 (a) How was the scene rendered differently with each lens?

 (b) Did you have to change the exposure to compensate for a slower lens (a lens with a larger minimum aperture than another lens)?

(c) Are all of your lenses equally sharp?

(d) What are the benefits of using a fixed focal length lens?

(e) What are the benefits of using a zoom lens?

(f) If you shot with a zoom lens, how easy was it to change between the focal lengths? Are all three images sharp?

(g) Which lens produced the best image? Why?

There are no right answers here; rather, the intent is to take an honest look at your lenses and see how you feel about them. Even though there are situations in which a zoom lens might be easier to use, I often prefer to use a 105mm fixed focal length lens that is incredibly crisp and reliable. This assignment isn't about finding images that you like; it's about finding tools that you like. If you enjoy using your equipment, you are more likely to keep shooting, and that should always be the goal.

8. In many photo editing programs, such as Adobe Photoshop, you can tile multiple images on your screen so that you are able to look at all of them at once. If you have this ability, use it.

2.10 This time I'm using Adobe Bridge. The same information is available in both Adobe Bridge and Adobe Lightroom, and I can also easily tile the images to see the various distances from the main subject shot with different lenses.

9. Now, crop each image so that it is approximately the same as the image taken with your longest focal length lens (in which your distant detail appears to be closest to you).

Here's what I mean. Let's use our 300mm image as the starting point.

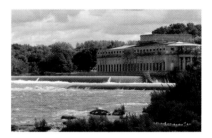

2.11 This is our 300mm image again. For this part of the assignment, we are going to use this as our gold standard and crop all of the other images to try and get this image.

Now let's crop our 200mm image so that it is as close to the 300mm image as possible. To do that, I am going to open the 200mm image in Adobe Photostop CS5 and use the Crop Tool.

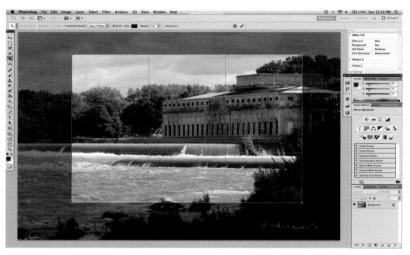

2.12 In Adobe Photoshop CS5 you have the option to create your crop with a translucent or blacked-out crop border for preview purposes. In this example, I left the crop border translucent so that you can see what I am doing. The clear part of the frame contains the information in the 200mm image that matches our 300mm, and the slightly darker part of the frame is what will be cropped out.

▶ Here are all six images, starting with the 300mm, all cropped to the same general frame. Note the vast differences in resolution and image quality. Even though the 300mm, 200mm, and 105mm lenses are comparable for reproductions at this size, we can see that the 50mm image lost some of its resolution, and the 36mm and 17mm images are very poor quality.

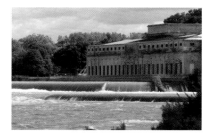

2.13 This is our cropped 200mm image. I know it looks a lot like our 300mm image, but that's the goal! You can see a few discrepancies in the crop, but this is certainly close enough for us to evaluate the final crop against the original.

2.14 300mm original

2.15 200mm crop

2.16 105mm crop

2.17 50mm crop

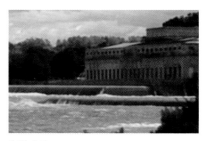

2.18 36mm crop

2.19 17mm crop

This may seem like a strange exercise, but it is beneficial for two reasons:

(a) Sometimes you won't be able to get close enough to get the final image that you want, but you can get the same image with a crop. It is helpful to know which lens will get you a shot closest to the one you want without cropping out vital information.

(b) Sometimes you won't be able to get the depth of field that you want, so using a shorter lens and cropping the resulting image will enhance your depth of field without requiring you to change your position or sacrifice your shutter speed.

10. Now evaluate the cropped images based on the following questions (again, record your answers in your notebook; you won't be able to make these types of crops and test images in the field):

(a) Which image has the greatest depth of field?

(b) Which image is the sharpest?

(c) When, if ever, does the resolution of the image start to deteriorate to the point that is no longer useful?

(d) Do you think that framing wide in camera and cropping in post-production is a valuable method of photographing? Why?

Again, there are no right answers. If you want to get it right in camera every time, now you know that. If you didn't know that you could crop and still get good results, now you might be able to get a shot you didn't think you could. Another benefit of this portion of the assignment is a closer evaluation of the true clarity of certain lenses as compared to others. This is not a true test of crisp focus, as you would need to be able to fill the frame with the same subject for each lens to really evaluate the lens's sharpness, but it will let you know if some lenses render small details better than others. Truly knowing the benefits and limitations of your basic equipment will enable you to be in control of your photography.

At this point you have completed the first two assignments. You have a working knowledge of your equipment, as well as confidence in the precision of your camera and meter and the clarity and flexibility of your bevy of lenses. We have a few more assignments that focus on the technical aspects of your photography and equipment, and then we will get into assignments that push your new skills as well as your creativity, so keep going! You're already well on your way to being the best photographer you can be.

Section B
Color Counts

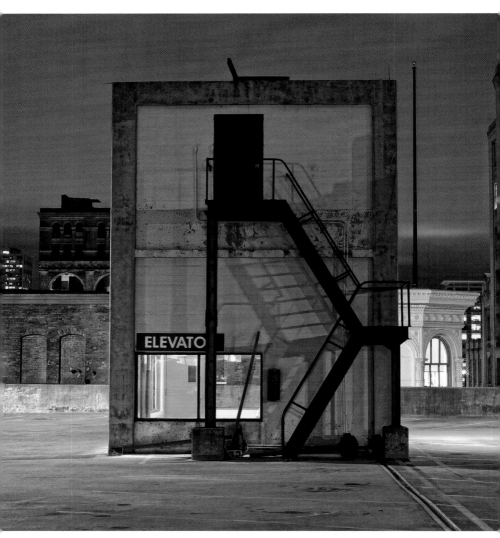

Elevator © Michael Penn. Courtesy of the artist.

One of the benefits of digital photography is that you can capture an image under any lighting situation with any color cast and it can be neutrally balanced or adjusted in whatever artistic way you see fit. With film, you could choose a balanced film and use gels, color temperature meters, and specific lights to get a neutral image, but now you can do it with the click of a button.

The trouble is, a lot of photographers out there don't know why they should or how they can change the white balance in their cameras, and every image they shoot either ends up being slightly off or has an inherent color cast that they intend to "fix in post." Either of these situations is not best for your photography. The best thing you can do for your images is to photograph correctly in camera and adjust the results to your taste later. If you never color correct any situation, chances are your images will be incorrect most of the time. If you expect that you can "fix it in post," you are shortchanging yourself and your images. Getting it right in camera allows you the latitude and flexibility to manipulate your images during post-processing, but you won't ever have to worry about "fixing" them. Now that we are learning how to control our photography, we want to shoot accurate images. We don't want to fix poorly shot images after the fact.

You are already on your way to better photography because you have determined how your equipment works together. But no matter how accurate your exposures are, if you don't capture light with the correct color balance, you don't correctly capture the scene.

What do I mean by that? It's all the same information in just a different orientation, isn't it? Well, not exactly. Think of it this way: When you select a white balance on your camera presets, your camera's brain places a curve on the incoming data to account for the natural shift in light. For example, your camera may filter out orange light from a tungsten-lit scene, or filter out blue light from an open shadow-lit scene. In each of these instances, your camera expects there to be a color bias to the scene based on the preset you selected. The filtration that your camera applies to the scene neutralizes the light coming in so that a neutral tonality will be neutral, meaning whites will look white, grays gray, and blacks black. In addition, every other color will be more closely represented by its actual color, rather than being shifted toward the color of the light source. Keep in mind that we determine *actual* color by what color things appear to be when they are under sunlight (or daylight)—the most powerful light source that we have always had since the dawn of time, and what is defined as white light.

Now think of this: If you don't select a preset, your camera doesn't place a curve on the incoming light, but rather records the bias

presented by the light source. The resulting data formed on the sensor and transmitted to your memory card will be skewed, and retrieving the actual perceptual differences later—in post-processing—will render the images differently than if you had correctly exposed all channels to begin with.

The Auto white balance feature on your camera is even worse. It reads the scene and assumes that whatever color has a greater impact on the reading is creating a bias in the scene. But what happens if you are photographing a blonde model in a yellow shirt in front of a yellow backdrop? Your Auto white balance will misunderstand the bias it reads and filter out some of the beautiful yellow you are trying to capture. Remember, we are no longer on auto pilot. We are avid photographers, working toward taking control of our photography. Auto is, after all, a four-letter word, so no more auto exposure, auto ISO, or auto white balance. We're better than that.

© Chuck Place, Brooks Institute. Courtesy of the artist.

What Will You Need?

Let's keep using our tested, tried and true equipment for this and all other assignments. All digital camera systems have some capability of changing white balance, either by presets or by custom white balance settings. Again, reference your camera manual to find the access point for your white balance changes. You'll be using those a lot from now on, so the sooner you get comfortable with them, the better.

What I Recommend

- Your manually adjustable camera
- A tripod
- A handheld meter
- An easily moveable object with varied colors
- Various lighting conditions—ideally, these should include every variation of light that matches your presets
- A notebook and pencil
- A computer
- Photo management software to open files and evaluate exposures

Purpose

The purpose of this assignment is to experiment with your presets under controlled conditions so that you can truly understand the accuracy of your preset white balance choices. At the end of this assignment, you will know what your object looks like under each lighting condition, and how the presets alter that object and correct for the light bias. How you choose to use that information is completely up to you, but the most important tool you have is your own understanding.

Procedure

1. Set Up – Because we will move through a variety of lighting situations, you don't need to use your tripod, but if the light is dim (which will likely be the case with at least some of the lights) a tripod will help you achieve sharp focus so that you can see your object clearly.

2. Initial Camera Settings – Set your camera white balance to Daylight. We are going to start out in direct sunlight and use this opportunity to set our baseline. Remember, this is how we define white light, so this image should portray the actual colors of your object.

3. With your handheld incident light meter, read the light and set your camera appropriately.

4. Take your first shot in daylight, with the Daylight preset.

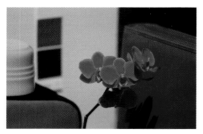

3.1 Since sunlight is the most prevalent light source and what we consider white light, this image should represent the true tonality of all of the objects in this scene. I didn't exactly follow my own advice and choose an easily portable object, but I wanted to show you a scene that demonstrates a wide variety of colors, textures, and surfaces, and that has some neutral tonalities. I included the QP-Card so that we could have a legitimate neutral to evaluate in our photo processing software.

5. Take your second shot in the same location and with the same set up, but this time, switch to Auto white balance so that you can see the differences. Keep track of your images in your notebook! Although your post-processing software will show you the "as shot" color balance data for your image, it will not show you what preset was selected at the time of the shot.

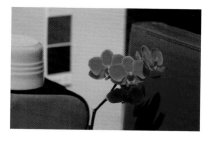

3.2 This image was taken with the Auto white balance tool selected in camera. It still seems pretty close to neutral, though maybe a little more blue.

6. Now, move your object, camera, and tripod to a new lighting situation and take a new meter reading.

7. Under this new lighting condition, take your first shot with the appropriate preset selected. (For instance, in open shade, pick the Shade or Cloudy preset. They are slightly different, but not every camera has a white balance preset for shade. Are you starting to see a problem?)

3.3 Here, I placed the same objects in approximately the same orientation in open shade. My camera has an Open Shade preset, so that's what I selected for this image. Besides the color shifts that we can begin to see, notice the variances in the way the objects are lit. When compared to the objects under daylight illumination, these objects have softer shadows, less texture, and are overall smoother and more even. This is something else to keep in mind with this project. You can tell a lot about light from these images besides just the color balance.

8. Using the same meter reading under the same lighting conditions, select Auto white balance and expose an image, just as we did in the first lighting situation.

3.4 The same open shade scenario with the Auto white balance setting.

9. Lastly, in this same lighting situation, take a shot using the Day-
light preset. This is the most prevalent situation and the most-used
white balance setting, so it is helpful to see the differences between
this shot, the shot taken with Auto white balance, and the shot
taken with the appropriate preset.

3.5 The same open shade scenario with
the Daylight white balance setting.

10. Now, repeat steps 6–9 for each of the presets that your camera
offers. It might be difficult to find the various fluorescent lights, or
wait for a cloudy day as opposed to a bright, sunny day, but that is
the point. There are many different lighting situations and slight
variations, and you need to learn how to approach any situation and
get the shots you want.

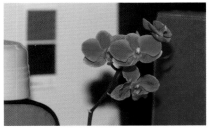

3.6 Flash lighting with Flash preset.

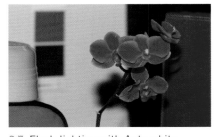

3.7 Flash lighting with Auto white
balance setting.

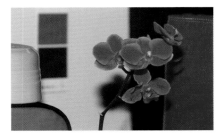

3.8 Flash lighting with Daylight preset.

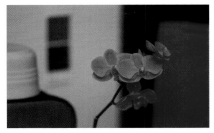

3.9 Tungsten lighting with Tungsten
preset.

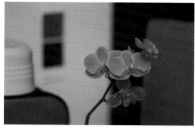

3.10 Tungsten lighting with Auto white balance setting.

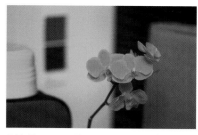

3.11 Tungsten lighting with Daylight preset.

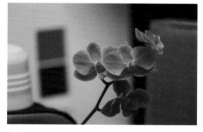

3.12 Fluorescent lighting with Fluorescent preset.

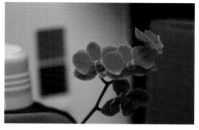

3.13 Fluorescent lighting with Auto white balance setting.

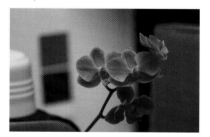

3.14 Fluorescent lighting with Daylight preset.

◀ ▲ Here are three other lighting situations that match the white balance preset options on my camera—Flash, Tungsten, and Fluorescent (in addition to the Daylight and Open Shade presets already reviewed). When you look at all of them next to each other you can see when the Auto function fails, when the preset fails, and when each is successful. Again, your results will vary from mine depending on your equipment, but the whole point of doing this is to understand when you should use each setting to get the best possible image.

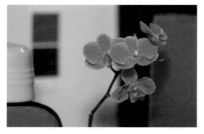

3.15 Flash with the Gary Fong Light-sphere on Flash preset.

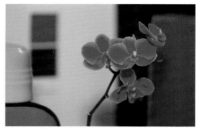

3.16 Flash with the Gary Fong Light-sphere on Auto white balance setting.

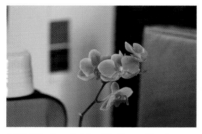

3.18 Window light with Open Shade white balance preset.

3.19 Window light with Auto white balance setting.

3.21 Overcast lighting with Open Shade white balance preset.

3.22 Overcast lighting with Auto white balance setting.

11. Since you were very diligent about taking notes, this next part may be a bit tedious, but trust me, the results will shock you and provide excellent information that you can use in your photography forever.

3.17 Flash with the Gary Fong Light-sphere on Daylight preset.

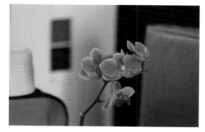

3.20 Window light with Daylight preset.

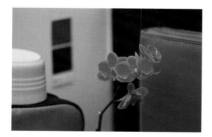

3.23 Overcast lighting with Daylight preset.

◀ Here are three other lighting situations for which my camera does not have a specific white balance preset. For each of these, I tried to pick the closest white balance option for the first shot. Without testing them, you'll have to make your best guess based on the lighting situation. For each image, I used one of the following setups: the Gary Fong Lightsphere over my flash unit with the white balance set to Flash; window light with the white balance set to Open Shade; or light from overcast skies with the white balance set to Open Shade.

12. Download all of your images to your computer and open them in your photo editing software. First, look at how the object relates to each lighting situation. In images for which the white balance wasn't adjusted, the color should be all over the place. But what happened when the white balance was adjusted? Does the object look correctly adjusted in every situation? What I'm hoping is that you find an image in which the object is pretty close to being correctly adjusted, and you can now manipulate (remember, we aren't fixing) the image in post-processing to make it look the way you want it to.

3.24 I used Adobe Lightroom 3 to review my images. From this thumbnail perspective, it's easy to see just how varied the "white balance" is for each of these settings. You can see when the image has a blue, magenta, or yellow cast as compared to the neutral starting point.

13. Now, take the images that weren't corrected—the ones for which you used the Daylight or Auto white balance setting—and select the appropriate white balance correction for each image in your software. (Your software should have a drop-down menu that allows you to pick Daylight, Cloudy, etc.)

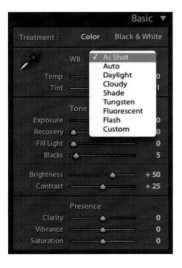

3.25 This is the Adobe Lightroom 3 white balance preset menu. The presets available in this menu are not necessarily the same as those available on your camera.

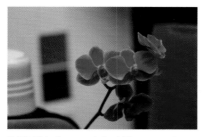

3.26 This is our original Fluorescent lighting situation with the Auto white balance preset chosen in camera.

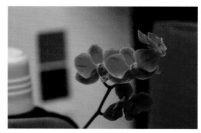

3.27 This is the same image as shown in figure 3.26 with the Fluorescent white balance preset chosen from the Adobe Lightroom 3 drop-down menu.

3.28 This is our original Fluorescent lighting situation with the Daylight white balance preset chosen in camera.

3.29 This is the same image as shown in figure 3.28 with the Fluorescent white balance preset chosen from the Adobe Lightroom 3 drop-down menu.

▲ These images show how the presets in the camera and the presets in Adobe Lightroom 3 can work together to try and create the best possible white balance for the image. In the first pair of images, the Auto preset, used under fluorescent light, created a blue cast over the image, and the Adobe Lightroom 3 preset brought it back to a neutral tonality. In the second pair of images, the Daylight preset, used under fluorescent light, created a yellow cast over the image, and the Adobe Lightroom 3 preset brought it back to a neutral tonality as well. But notice how neither of these "neutral" images ultimately recreates the original tonality very well.

14. You should do this exercise with each set of images and evaluate what you find. You are going to end up with dozens of images with varying color casts, saturation, neutrality, and appeal that only you can decide to incorporate into your photography. For the purposes of this assignment, and in the interest of saving paper and time, I have only provided you with the preset neutralized images for one lighting condition. But you should go through the process of neutralizing all of your images to see what you get and to better understand your equipment.

15. If you don't have a drop-down menu, you may have a white balance neutral target selection tool. In Adobe Lightroom 3, this is located next to the drop-down list for the white balance presets. If you cannot, or did not, shoot in RAW, this target neutralizer can create neutral images, but you have to have a neutral density in your images, such as a Kodak Gray Card or the Digital Gray Card we used in the first section.

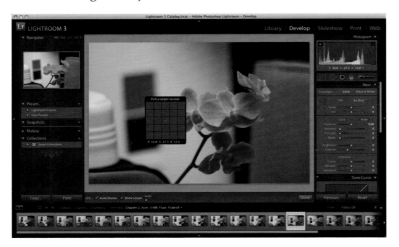

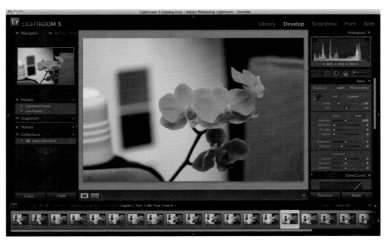

3.30 These two images demonstrate the process of selecting the neutral target selection tool in your image to create a custom white balance. The more yellowed image was taken using the camera's Fluorescent white balance preset, which is clearly not very accurate for this particular light. The neutralized image is certainly closer to accurate, but you can see banding in the colors, and the overall scheme is not very close to the normal scene we are comparing it to.

16. Below, notice the differences when I use the neutral target selection tool to adjust the white balance on the same set of images that I previously neutralized.

3.31 Image shot in Fluorescent light with the Daylight white balance preset selected in camera and the Fluorescent white balance preset selected from Adobe Lightroom 3.

3.32 Image shot in Fluorescent light with the Daylight white balance preset selected in camera and the Adobe Lightroom 3 neutral target selection tool used for white balance in post-processing.

▲ As you can see in this set of images, each white balance method that you apply will create vastly different ultimate results. The further from neutral your original captured image is, the more skewed your final results will be, no matter how many neutral test targets you place into your scene. The best thing you can do is to determine the most accurate combination of white balance techniques to which you have access for each of your images. Of course, you can also evaluate what "wrong" techniques create a style, feel, or look that you might want to apply to certain types of images in the future.

17. Evaluate the neutralized images. How close are they to the "correct" version of the image? You can use Adobe Lightroom 3 or Adobe Bridge to view all of your final images as thumbnails in one location, which makes it easier to compare and evaluate them. Both of these programs also allow you to look at individual images in greater detail if you choose to, so they are an excellent way to evaluate the whole assignment as well as the individual results. Look at the saturation, the color contrast, the gradation between the different colors, the object itself. What do you see? Are all the images the same? Are there tangible differences? What do *you* like? [▤ 3.33–3.40]

18. Take notes about the way the light interacts with the subject as well. Note that the shadow cast from the object under direct sunlight is harsh, sharp edged, and dark, whereas the shadow in open shade is soft, has an even gradient, and is much lighter than the other shadow. Whatever subject you choose to shoot in each lighting situation will react basically the same. Texture, bumps, wrinkles, and reflective surfaces will react differently in hard light (which we photographers call specular light)

3.33 Daylight

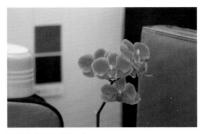

3.34 Open Shade

3.35 Flash

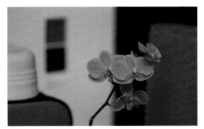

3.36 Tungsten

3.37 Fluorescent

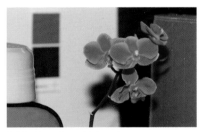

3.38 Gary Fong Lightsphere

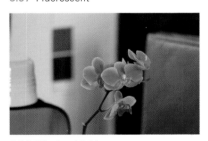

3.39 Window Light

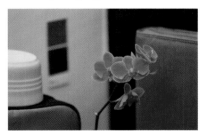

3.40 Overcast

▲ Since we are not using a custom white balance for each lighting scenario, we should always start with the in-camera white balance preset that most closely matches the lighting conditions, and then use our post-production software to complete the process. Here I started with the preset that was closest to neutral, and then further neutralized the white balance with the Lightroom 3 neutral target selection tool. There is a noticeable difference in white balance results before and after post-production.

than in soft light (diffuse light). Really look at each image set to see what kinds of subjects might be good in which kinds of light. And, maybe more importantly, which kinds of light won't do certain subjects any favors.

Now that you have completed this assignment, you know how each preset works and what sort of color shifts and changes you get when you alter the presets in camera or adjust the white balance in post-processing. The purpose here is not necessarily to convert you to my way of thinking (which is to always adjust as much as you can in camera to get the desired results) but to provide you, through your own efforts, with a better understanding of white balance, color, presets, and what your camera can do to compensate for the variety of light you will encounter while photographing. Now that you know, you make the choice. Giving you that choice is my primary goal. If you choose to stay with Auto white balance given everything that you have done, that is your right. (I did just die a little on the inside; but no matter, it's your photography.)

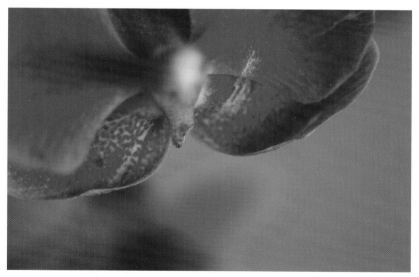

3.41 The goal of all of these tests is ultimately to be able to pick the ideal settings for your imagery to get the final result that you want. With this particular test, I noticed how lovely the orchid looked against the cyan colored background and decided to create a macro shot of just that combination. I used the window light setting with the Daylight preset because I liked the slight warmth that the daylight white balance added to the image. Note: I cannot change this tonality with the neutral target selection tool because there is nothing neutral in this image! Be aware of the possibilities and drawbacks of your software, including how you change your images in post-processing.

What I hope you learned in the previous assignment is that the color of an image is affected by the settings you choose on your camera. The more precise we are in handling our equipment, the more we control the outcome of our photography.

At this point we have shed the automatic modes, refined our exposures, and learned how to employ the best white balance for various situations. But the preset white balance settings are not perfect. In fact, they are far from it. They can predict how light will work and the color shifts that it will produce, but since they are general algorithms for the most common situations, they can't be precise in all situations. Your camera, on the other hand, can.

With a little bit of coaxing, your camera can provide a custom white balance for any lighting situation. Does that mean you always want to do a custom white balance? Not necessarily; for instance, you wouldn't want to correct the beautiful orange tones of sunset and the warm glow cast on a subject's face. But the next lesson will give you the knowledge and ability to be able to custom white balance should the opportunity arise.

THE PERFECT BALANCE

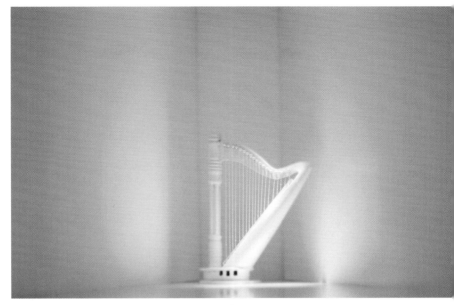

Harps and Their Sound © Robert Bradshaw. Courtesy of the artist.

What Will You Need?

You can choose to use the same object that you were using before or change it up. Either way, make sure you use the same object in each of the following situations so that you have a consistent variable to review at the end of this assignment.

What I Recommend

- Your manually adjustable camera
- A tripod
- A handheld light meter
- A WhiBal card (or gray card)
- An easily moveable object with varied colors
- Various lighting conditions. Ideally these should include every variation of light for which your camera has a preset.
- A notebook and pencil
- A computer
- Photo management software to open files and evaluate exposures

Purpose

The purpose of this assignment is to get precise white balance results in any situation using the custom white balance function in your camera. This process will provide your camera sensor with the appropriate information to accurately balance the light hitting your WhiBal or gray card. Because your balancing tool will dictate the accuracy of your final image, it is important that the tool be as accurate as possible. If you are using a gray card, make sure that it is clean and free of stains, smudges, dirt, or particulate of any kind. For more precise control, I recommend using a WhiBal card, which is specifically designed to aid your camera's computer sensor in acquiring perfect custom white balance. The cards are individually tested for accurate calibration. It is a relatively small expense for lasting and extraordinary results. Plus, using a WhiBal will save you headaches down the road.

Procedure

1. Set Up – Again, I encourage you to use your tripod for accurate focus, clarity, and presentation of your object. Until you set the custom white balance, though, keep your camera off the tripod so that you can get closer to your subject. Use your meter to find the appropriate exposure for the scene you are shooting, and then select the appropriate white balance preset. Take your first shot.

4.1 In this image, the white balance on the camera was set to sunlight, which appears to be correct.

2. Place your card in front of your object so that the light you want to balance (the main light for the object) is evenly illuminating your card. In other words, make sure the card is not at an incident angle to the light source; you want to be certain the card isn't reflecting light into the lens. The WhiBal card assists you with this because it has white and black swatches that are reflective—if the light source is hitting the card at an incident angle, you will see white reflections on those swatches. If that happens, turn the card slightly so that the reflections disappear. Now the card is at a non-incident angle to the light source and you can get an accurate reading.

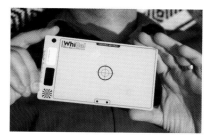

4.2 In this image, I want to white balance the light that is hitting the broad side of my subject's face. To ensure that I am getting an accurate white balance for that light, I am going to place the card in such a way that it is directly illuminated by the sun without being at an incident angle.

3. Initial Camera Settings – Here is where things get a little more complex than in the previous assignment. Rather than choosing a preset, you are going to have to access the custom white balance feature on your camera. When the camera indicates it, you are going to take an image of the WhiBal card in front of your object. You want to fill the frame with the card and take the indicated exposure. Unlike a gray card, the WhiBal card is not 18 % gray. Its purpose isn't to help with exposure, but rather to help with white balance, so it is manufactured to be a lighter gray that is easier for the camera to accurately read and adjust.

4. Once you take the image, the camera allows you to set the new white balance as the custom white balance setting. Accept this new setting and you have completed the custom white balancing of your camera for this light source.

5. Put the camera back on the tripod and frame your shot. Using the exposure that you determined with your meter, and the new custom white balance setting, take your first WhiBal white-balanced shot.

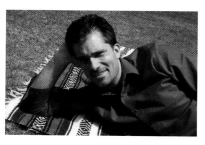

4.3 In this scenario, the WhiBal card made a very slight difference between the first shot and this new shot, so that is good to note. But in some cases, using the WhiBal card will allow you to accurately account for unforeseen circumstances, as we explore below.

6. We can now check to see how accurate the presets are. For each lighting situation, take one custom shot and one preset shot. It's important that you do these at the same time (don't use your previous assignment) because slight variables, such as time of day, location, composition, etc., could affect the overall color of the shot.

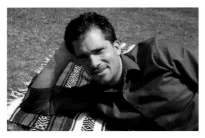 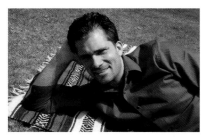

4.4 When viewed side by side, you can see the slight difference between the Day-light preset and the WhiBal neutralized shot.

7. Take your camera, object, and card to your next location and repeat steps 3–7 for each new setup.

4.5 In a scenario like this, the main light source is actually reflected ambient light from the surrounding area. But the surrounding area is bright green grass, so there is a green color cast across the subject even with the Open Shade white balance preset selected.

4.6 You can see this green cast when looking at the WhiBal card before it is neu-tralized and after. Remember, to actually get an accurate WhiBal reading, you need to fill the frame with the gray card; these images just give you an idea of where the card can be placed to accurately account for the color shift.

4.7 This neutralized image is much more appealing and natural looking. The subject no longer looks green, and the surrounding background appears to be the correct color.

8. Now create a different type of lighting situation. Try throwing a red gel over your lamp, or hang some Christmas lights, or light your background with a fluorescent bulb and your foreground with a tungsten

bulb. Decide which of the multiple sources you would like to have neutralized and place the WhiBal card in that light. Play around here and have a little fun. Try balancing different parts of the frame to see what different color schemes you can get. Try the presets here as well, and see if they can accommodate for the variety of colors that you are creating.

4.8 Though this may not be as flashy as concert lighting or the lit-up strip in Las Vegas, the subtle warmth created by the use of ambient light as an edge light in this otherwise open shade scene creates a different effect than in a straight open shade scenario. You should definitely try extraordinary and fun combinations, but don't forget that sometimes, subtle additions can make all the difference.

9. Download all of your images and pull them up in your photo editing software. What differences do you see between the custom and the preset images? How are they better or worse? Can you even see a difference? How well do your presets work? What about the situation with multiple lights? Do you like the results that you got?

NOTE You can do this entire assignment with a gray card as well, but the results may not be as accurate as with the calibrated WhiBal card. The results should be better than what you would get without using custom white balance in either case.

I want to reiterate here that the main goal is for you to be able to *choose* how you proceed. If you want precise color renditions, or exactly neutralized white balance, you now have the tools and know-how to do that. If you want to play with color or throw an intentional cast on a scene for an artistic or metaphoric purpose, you can look at the uncorrected images and find something that suits your liking. But at least now you will be calling the shots. If you really want to go above and beyond, create a catalog of images of your object in every color situation with the *wrong* color preset selected. What happens when you use a tungsten preset in daylight, or a fluorescent preset in open shade? If you create a catalog like this, you will quickly be able to determine which type of color bias you would like to use for artistic purposes. With this knowledge, you can create any type of feeling or ambiance you want in an image without having to wonder if you could achieve that same type of look using photo manipulation software after the fact.

Section C
Exposing Exposures

© Chuck Place, Brooks Institute. Courtesy of the artist.

This is fantastic! At this point we have calibrated equipment, knowledge of what our lenses can do, an understanding of white balance and how to use it, and the perfect foundation for all the images that we've ever wanted to create with natural light, in any lighting situation. So now what? Aren't we ready now?

In some ways, yes. We are ready to go out and find any subject that we want to photograph and go about capturing that image. All of the exercises that we have done up to this point have prepared us for this moment. What we need to understand now is how to get the perfect exposure for the scene we want to shoot. What you choose to shoot at this point is up to you, but start with the knowledge you have built up, and find what type of light, white balance, and lens you want to use to get your image. You can choose whatever subject you want for these exercises so long as you follow the guidelines established in the assignment. This will make more sense when you read on.

Don't push yourself too hard right now; you want to have a little patience. You should have done all the other assignments up to this point, but that doesn't mean that you have a lot of practice yet. As each assignment builds on the last assignment, you have the opportunity to review your skills, solidify your knowledge, and continue to grow. The best photographers are the ones that keep shooting.

So what is exposure, exactly? The exposure of your image is the setting at which the scene will appear normally rendered, with an appropriate dynamic range between the highest values (whites or highlights) and the lowest values (blacks or shadows). Even with the best technology, you can't necessarily capture detail over the entire dynamic range of a scene, so the appropriate exposure is also the exposure that biases toward your subject.

If your subject is a woman standing in shadow, the appropriate exposure of her would be balanced for shade (custom or preset), bright enough to bring her skin tone to a normal level while maintaining highlight detail in her eyes and shadow detail around her. In this situation, if part of the scene is in direct sun, that portion of the scene will be brighter, washed out, and a little overexposed. That's okay. The nature of the dynamic range in this image prevents us from being able to capture all the detail in that lighter part of the frame as well as the detail in the shadow portion. In this case, though, we chose to bias our exposure toward the subject. In the opposite scenario, a portrait of a woman in the sun, you would lose the shadow detail in the darker parts of the frame. Either way, you choose what your exposure will be and set your camera accordingly.

So how do you choose? In assignment 1, when we performed an EI test for our camera, we used an incident meter. This is the ideal tool

to use because it will always give you precise data (once calibrated, which ours is!) and tell you the exact combination of shutter speed and aperture that you will need to use to expose your subject. But this isn't the only way to determine proper exposure. In assignment 5, we are going to evaluate something called equivalent exposures. That is to say, we are going to take our meter reading, and then adjust the camera settings not only to appropriately expose our scene, but also to use the other techniques we have learned to create the image that we previsualize. In assignment 6, we are going to discuss a number of exposure methods that allow us to work with our available equipment to get an appropriate exposure for a variety of scenes. By the end of this section, you will be able to correctly expose any scene and accurately render even some of the most difficult subjects.

5.1 Throughout this assignment, the ways in which these two images differ, and are yet the same, will become clearer. It is important to note that the top image was shot at ¹⁄₁₅ sec at f/2.8 and the bottom image was shot at 4 sec at f/22.

© Tom Flory. Courtesy of the artist.

Before we get started with equivalent exposures, we need to discuss how they work. Once you get out into the field with this information it will solidify for you, but we have to consider the theory a little first.

Exposure on your camera sensor or film is created by light hitting the imaging surface. Light reaches that surface through the lens and is quantified by your aperture, shutter speed, and ISO information. You can think of the light like water from a hose filling a bucket. The bucket is your imaging surface, the diameter of the hose is your aperture, and the time it takes the water to fill the bucket is your shutter speed (also time). With a wider hose, the water would fill the bucket quickly, making the time shorter. With a smaller hose, the water would take longer, extending the overall time. In the end, the combination of aperture (diameter of the hose) and shutter speed (time) equals the overall exposure (full bucket).

The formal equation is $E = I \times t$, where E = your exposure, I = the intensity of light as allowed through the lens by the aperture, and t = time.

If you can wrap your head around the bucket analogy, you can see that there are multiple combinations of apertures and shutter speeds that could ultimately give you the same exposure. But I'm not going to force you to experiment with every scene until you get an appropriate exposure. The components of exposure that we are going to be concerned with are called stops. If you add a stop of light, you double the amount of light hitting the imaging surface. If you remove a stop of light, you cut the amount of light hitting the imaging surface in half. Each full f-number is one stop, as is each full shutter speed. You may

remember from your EI test that your camera has either ½ stops or ⅓ stops between each full stop. This allows you even more possibilities and better accuracy with your equipment. But for the purposes of this assignment, we are going to work with full stops to try and get you used to the numbers before we introduce more complicated divisions.

If we have a meter reading that tells us a specific aperture and shutter speed and we want a different aperture and shutter speed setting, we need to use equivalent exposures to find what the new aperture and shutter speed settings will be. We do this by inversely adjusting the aperture and shutter speed by equivalent stops. That is to say, if we close down the aperture one stop (go from a low f-number to a high f-number), we need to compensate by slowing down the shutter speed by one stop. Because we have cut the intensity of light hitting the imaging surface by half, we need to allow more time for the light to get to the imaging surface. Similarly, if we open up the aperture one stop (go from a high f-number to a low f-number), we need to speed up the shutter speed by one stop to compensate.

For your reference, here is a list of full stop shutter speeds and apertures available on most prosumer cameras. If your camera goes beyond these limits, just remember that you halve or double the light with each stop. For shutter speed, you can multiply or divide the existing value by two to get the next or previous value (the noticeable exceptions are the difference between ⅛ and ¹⁄₁₅ and ¹⁄₆₀ and ¹⁄₁₂₅.).

Apertures
f/1.4, f/2, f/2.8, f/5.6, f/8, f/11, f/16, f/22, f/32, f/44, f/64

Shutter Speeds
1sec, ½, ¼, ⅛, ¹⁄₁₅, ¹⁄₃₀, ¹⁄₆₀, ¹⁄₁₂₅, ¹⁄₂₅₀, ¹⁄₅₀₀, ¹⁄₁₀₀₀, ¹⁄₂₀₀₀, ¹⁄₄₀₀₀

Hopefully this is starting to make sense. Let's get to the assignment and start practicing.

What Will You Need?

In this assignment you are going to start crafting certain elements of your photographs by utilizing appropriate combinations of shutter speed and aperture to capture the image the way you previsualize it. That is to say, you aren't going to give yourself over to the automatic mode or merely put the meter data into your camera; you are going to make choices based on the situation, the elements in the scene, your desired final image, and the visual effects achievable with your lens system.

What I Recommend

⊕ Your manually adjustable camera
⊕ A tripod
⊕ A handheld meter
⊕ A WhiBal Card
⊕ A gray card
⊕ A scene that you want to photograph during the day
⊕ A notebook and pencil
⊕ A computer
⊕ Photo management software to open files and evaluate exposures

Purpose

The purpose of this assignment is to give you flexibility with your meter reading and to give you control over your final image. Once you understand how equivalent exposures work, you'll be able to evaluate every scene that you photograph and allow for blur or stop action, or maximize or minimize depth of field.

Procedure

1. Choose your scene.

 (a) See if you can find a scene that has elements at various distances from your camera: close to the camera, mid-range from the camera, and far from the camera. (Depending on your lens as well as your chosen subject, these elements can actually be very close to you and you can still get the ranges we need to demonstrate the assignment, so pick something that you would like to have as a final image.) You should also try to find a scene that has some motion. (If you have a very patient assistant, they can provide the motion, but a busy street, a flowing stream, or a trolley station would work just as well.) Find a subject that is at the mid-range distance and focus on that subject for the entire assignment.

 (b) I recommend a scene lit during the day because it will give you more flexibility to truly experiment with equivalent exposures. The more light you have to work with, the more latitude you have to create as many equivalent exposures as your camera system will allow.

2. Set Up

 (a) Set your camera on a tripod so that all of the images will show the same perspective of the same scene.

(b) Set your camera ISO to 100. For the purposes of this assignment, we aren't going to change the ISO; but if you are interested in what happens when you modify the ISO, refer to the Special Note at the end of this assignment.

(c) Use your incident meter to take a reading of your scene at your camera's widest aperture (which will be the smallest f-number). Write down this meter reading; this is your starting point.

3. Take your first photograph using the information from the meter. Make sure you capture the close, mid-range, and long-distance elements, as well as the moving elements. Remember to focus on a mid-range subject.

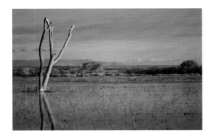

5.2 For this scene, the reeds closest to the camera, the dead tree in the marsh, the landscape on the water's edge, and the mountains create four planes in the image, from very close, to moderately close, to mid-range, to infinite. In this image I focused on the far coast, even though I would normally focus on the dead tree, which is a clear subject. Yet, for this process, evaluating how the dead tree becomes more out of focus as depth of field changes is a valuable exercise, so for each of the next series of images, I focused on the two trees closest to the center of the image. You can see how the reeds closest to the camera are out of focus, as is the tree's reflection. The dead tree in the water is also slightly soft, though it is not as easy to tell without evaluating the whole image more closely.

4. To make an equivalent exposure of the same scene, we want to make equal, inverse adjustments to the shutter speed and aperture.

(a) For this assignment, my starting meter reading was f/2.8 @ ½₀₀₀ sec. If I adjust from f/2.8 by one stop, that would leave me with f/4. If I want the exposure to be accurate, I now need to slow down the shutter speed to ½₀₀₀ to compensate.

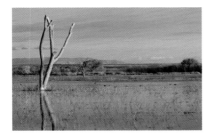

5.3 This is clearly the same scene, but with some slight differences in depth of field. Notice that the background seems relatively crisp, even though the foreground is still blurred. The relative distance between you and the objects in your scene will determine whether the background looks out of focus or crisp, even when you are focused on an object that is nearer to the camera than the horizon. This will be more evident in the next part of the assignment.

5. Now let's continue to make equivalent exposures for the entire range that our camera system will allow. For this example, your equivalent exposures may look like this:

f/number	shutter speed
2.8	$\frac{1}{2000}$
4	$\frac{1}{1000}$
5.6	$\frac{1}{500}$
8	$\frac{1}{250}$
11	$\frac{1}{125}$
16	$\frac{1}{60}$
22	$\frac{1}{30}$
32	$\frac{1}{15}$

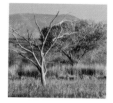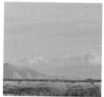

5.4 Samples taken from the four planes of the image shot at f/2.8 @ $\frac{1}{2000}$ sec.

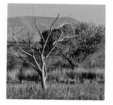

5.5 Samples taken from the four planes of the image shot at f/4 @ $\frac{1}{1000}$ sec.

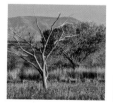

5.6 Samples taken from the four planes of the image shot at f/5.6 @ $\frac{1}{500}$ sec.

 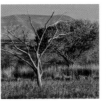

5.7 Samples taken from the four planes of the image shot at f/8 @ ¹⁄₂₅₀ sec.

 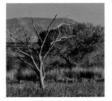

5.8 Samples taken from the four planes of the image shot at f/11 @ ¹⁄₁₂₅ sec.

 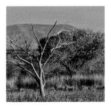

5.9 Samples taken from the four planes of the image shot at f/16 @ ¹⁄₆₀ sec.

 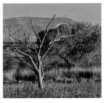

5.10 Samples taken from the four planes of the image shot at f/22 @ ¹⁄₃₀ sec.

5.11 Samples taken from the four planes of the image shot at f/32 @ ¹⁄₁₅ sec.

◀ Rather than looking at each individual image and trying to evaluate the differences in depth of field and exposure, let's look at the same sections of each image taken at different equivalent exposures, and evaluate the four planes of the scene we mentioned earlier. Here, we are looking at increasing depth of field, going from a very blurred foreground at f/2.8 to a relatively clear foreground at f/32. The other important thing to notice here is that the tonalities of each exposure are the same. The only variances are the depth of field and the slight motion blur resulting from the slowest shutter speed, that of ⅟₁₅ sec at f/32.

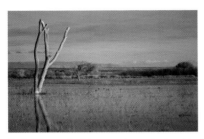 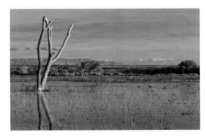

5.12 The easiest images to evaluate side by side are the original shot, taken at f/2.8 @ ⅟₂₀₀₀ sec, and the last shot, taken at f/32 @ ⅟₁₅ sec.

6. Now that we have completed our first set of equivalent exposures, find a new location that is darker, such as a park shaded by large trees. Don't make your exposures at dawn or dusk because during these times the light quality and intensity changes rapidly and your test won't be accurate. Once you've chosen a new location, set up your scene in the same way you set up the first scene, making sure you have close, mid-range, and long-range elements, as well as motion.

7. Take a new meter reading at your widest aperture and set the meter reading into the camera. [⬅ 5.13]

8. Now proceed to make a full range of equivalent exposures of your new scene. You may end up with some very slow shutter speeds, so be sure that you use a tripod and that all your images show the same perspective of your scene. For the example on the following page, your exposures may look something like this:

f/number	shutter speed
2.8	⅟₅₀₀
4	⅟₂₅₀
5.6	⅟₁₂₅
8	⅟₆₀
11	⅟₃₀
16	⅟₁₅
22	⅛
32	¼

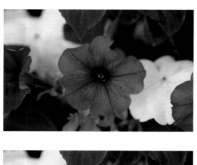

5.13 For this set of images, I chose a shaded flower garden with petunias. In this case, there was a slight wind blowing, which will become evident later in the process.

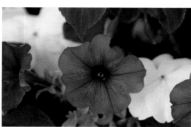

5.14 f/5.6 @ 1/125 sec

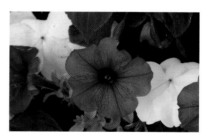

5.15 f/8 @ 1/60 sec

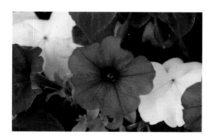

5.16 f/11 @ 1/30

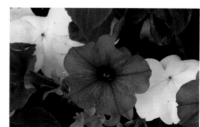

5.17 f/16 @ 1/15

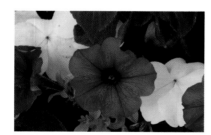

5.18 f/22 @ 1/8 sec

5.19 f/32 @ 1/4 sec

▲ You can see the increasing depth of field in this series of images if you look at the petals and leaves of the other flowers behind the main subject. In the final image shot at f/32, there is good detail in all parts of the image.

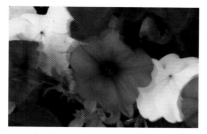

5.20 f/32 @ ¹⁄₃ sec with blurred motion due to the wind. Remember, though, that there is motion in this particular scene. The motion was caused by the wind, and there were times when the wind was blowing and times when it wasn't. I was able to get a perfectly crisp shot at f/32 @ ¼ sec by using a tripod and waiting for the wind to die down; but when I wasn't conscientious of my scene, this was the result. If there is constant motion in your scene, you should see an evolution of blur as well as an increase in depth of field.

9. You can continue to find new scenes and make new exposures until you feel comfortable with the process. At this point, it is extremely important that you review your results and evaluate the effects of each equivalent exposure.

10. When you open your images in your photo management software, you should notice one extremely important fact: Despite anything else that might be different in your images, the exposures are all the same. That is to say, all of your images have the same brightness, colors, and contrast. If you notice any differences among your images, you may have gotten off track somewhere and you should redo the test until you are comfortable. If they do match, you can be confident that you performed the assignment correctly.

11. Questions for you to consider:
 (a) What are the main differences between your first exposure and your last?
 (b) What happens to the depth of field as you close down the aperture?
 (c) What happens to the motion at the fast and slow shutter speeds?
 (d) What combinations of aperture and shutter speed are you most drawn to?
 (e) Can you think of specific situations in which you would like to use a low f/number and a fast shutter speed, or a mid-range combination, or a high f/number and a slow shutter speed?

12. Based on that last question, your final three images of this assignment involve you going out into the world and finding images that you think best utilize each combination. You should come back with three images at least, though this is an excellent opportunity for you to go out into the world and create new images that fit your tastes.

5.21 For this image, extreme sports photographer Steve Dutcheshen had to use a shutter speed of ⅛₀₀₀ sec to ensure that this motion was appropriately stopped in mid air. His knowledge of equivalent exposures allowed him to adjust his shutter speed and aperture before the athlete was in motion to get the perfect combination for this shot.
© Steve Dutcheshen. Courtesy of the artist.

5.22 For this image, photographer Sam Rivera used a mid-range combination of aperture and shutter speed—f/11 @ ¹⁄₁₂₅ sec—to stop the motion of the subject while also giving enough depth of field so that we can see all of her features clearly.

© Sam Rivera. Courtesy of the artist.

5.23 For this image, fine art photographer Glenn Rand used an equivalent exposure with a long shutter speed to allow for blur. The water rushing past these rocks blurred in such a way as to create an ethereal, painterly effect.

Point Lobos © Glenn Rand. Courtesy of the artist.

Once you understand the concept of equivalent exposures you can address any situation and find the correct combination of aperture and shutter speed to control your depth of field and stop or blur motion as you see fit. So long as you have access to your incident meter, you can always get the perfect exposure starting point and experiment with the settings to find the exposure that is not only perfectly exposed, but also renders the scene in a creative way that you have chosen.

The only trouble is, you may not always have your incident meter or be able to use it. So in the next assignment, we are going to learn how to deal with all types of exposure situations.

Special Note: With a modern digital camera, you have the ability to choose not only the aperture and shutter speed, but also the ISO setting. This modifies the previously explained exposure equation by adding an additional variable. Now, $E = I \times t \times ISO$. This means that if you change any level of sensitivity (I, t, or ISO) you have to adjust one other to compensate for an equivalent exposure. For example, you can change your aperture, leave your shutter speed the same, and change

your ISO to compensate. Because this adds a third variable, the possible combinations for any individual exposure are exponentially greater. If you ever find yourself in a situation where you cannot change either the aperture or the shutter speed, you do have the additional variable of the ISO that can be utilized to create an equivalent exposure.

ISO works in the same way as aperture and shutter speed in that when the ISO number doubles or halves, that is equal to one stop of light. So ISO 200 is twice as sensitive to light as ISO 100, and half as sensitive as ISO 400. You can calculate equivalency using the same logic, there are just more numbers to keep track of.

Here are a couple of examples from our first exposure set that would be adjusted due to the ISO. But remember, there are many, many more combinations than this.

f/number	shutter speed	ISO
2.8	$\frac{1}{4000}$	100
4	$\frac{1}{2000}$	100
5.6	$\frac{1}{2000}$	200
8	$\frac{1}{2000}$	400
11	$\frac{1}{1000}$	400
16	$\frac{1}{250}$	200
16	$\frac{1}{500}$	400
16	$\frac{1}{1000}$	800
44	$\frac{1}{500}$	800

© Kevin Osborn. Courtesy of the artist.

What Will You Need?

For this assignment let's bring along everything that we have that might help out with finding the perfect exposure. Even though you won't always have access to every piece of equipment, every method, and every scene exactly as you'd like, right now we can. Find a scene or area to photograph that allows you to set up shop. You want to have all of your equipment easily accessible and safe (don't bring it to the beach and then walk away to photograph a crab and turn your back on everything). So, one suggestion I have is to bring a spouse, sibling, parent, child, or friend. We call them assistants.

What I Recommend

- Your manually adjustable camera
- A tripod
- A handheld meter
- A WhiBal card
- A gray gard
- A scene of your choice with interesting available light
- A notebook and pencil
- A computer
- Photo management software to open files and evaluate exposures

Purpose

The purpose of this assignment is to lay the groundwork for you to understand exposure. Even with all of the other lessons that we've been learning, without precise exposure, your images can never reach their full potential. Remember what we were talking about with the color balance—we don't ever want to have to "fix something in post." When it comes to exposure, the "fix it in post" mentality means loss of detail in the highlights and shadows. Even though your software might have a recovery feature, it can't bring back what is lost due to incorrect exposure.

Procedure

1. Set Up – Find something you would enjoy photographing that is easy to get to, safe enough for you and your equipment, and has consistent lighting so you can experiment with all of these exposure techniques. Give yourself a good amount of time as well. With this assignment, you can photograph whatever you want for each step, so long as you are following the instructions for exposure. You can use your tripod, but I would recommend handholding your camera if the lighting allows so that you can walk around your area and explore a little. For each of these situations, take excellent notes! You will need them when you get back to your computer to evaluate your images. Without knowing what metering system made what image, you won't learn the most important lesson of this assignment—understanding your metering choices.

2. Initial Camera Settings – If you brought along your WhiBal card, go ahead and create a custom white balance for your scene. If not, select the preset that you think best represents the light in the scene. For the purposes of this assignment, don't try to create an artistic color balance look. We really want accurate information here to create the perfect exposures for evaluation.

3. EXPOSURE METHOD 1 – HANDHELD INCIDENT METERING

(a) The best method of determining the lighting of a scene is to use a handheld incident meter to read the light. An incident meter reads the light that is falling on the subject and calculates exposure data. The meter readings won't be affected by the color, tonality, or brightness of the subject, but will, in fact, render the perfect exposure every time.

(b) Hold your incident meter directly in front of your subject with the white dome pointed toward the main light source (if this is the sun, point your meter toward the sun; if you are in a shaded area, point your meter toward the brightest area around the subject that is bouncing light into the shade, etc.). You can tell where the main light source is by looking at the shadows in your scene. If the shadows are cast to the left, the main light source is to the right.

(c) Set your camera with the metered settings.

(d) Take your photograph.

6.1 This scene has a wide range of lighting and possible exposures, so it provides a good starting point for taking a baseline shot that we can use for this exercise. I used the incident meter to get an accurate exposure for the sunlit part of the wall and took the photograph.

(e) Feel free to take as many photographs as you like using your incident meter, but keep in mind that you can't necessarily get right up next to every subject that you want to photograph. The rest of the methods listed here are additional ways that you can correctly expose a scene, but we are going to use the incident meter readings as the baseline exposure for every scene we photograph for this assignment.

4. EXPOSURE METHOD 2 – HANDHELD SPOT METERING

(a) We are now going to take spot meter readings of the same scene using a handheld spot meter. If you don't have a handheld spot meter, skip ahead to step 5.

(b) A handheld spot meter has a viewing window that allows you to see precisely what part of the scene is being metered and adjust accordingly. You need to be able to find a tonality within the scene that is approximately the same value as middle gray.

(c) Use your gray card and the handheld spot meter to find the correct exposure for this scene. Adjust your camera according to the meter reading and take a baseline shot.

(d) With a spot meter, you will always get precise results with a gray card in the same light as your subject; but if you aren't able to place your gray card in the same light as your subject, try to find other middle tonalities that are already in the scene.

(e) Set your camera with the new readings and see what types of images you get. Take as many images as you want and evaluate which colors and tonalities were successful metering aids and which ones weren't.

6.2 For this image, I used the sunlit wall for my metering. You can see that the overall exposure is a little bit dark, which makes sense because the tonality of the wall is actually a little brighter than middle gray, so to compensate, the meter underexposed the scene.

6.3 For this image, I used the blue door for my metering. You can see that the overall exposure is a little bit light, which makes sense because the tonality of the door is actually a little darker than middle gray, so to compensate, the meter overexposed the scene.

6.4 For this image, I used the greenery beneath the tree for my metering. You can see that the image is very overexposed in this scenario.

(f) Now, find a scene that you can't get close to—a valley, a tall bridge, the other side of a lake—and try to get an accurate exposure. Spot metering works best with a gray card, but if you don't have access to your subject, you need to know what you can rely on to get the shot.

 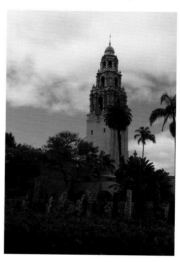

6.5 For these images, I used the handheld spot meter to try and get an accurate exposure. For the first shot, I metered the palm tree in front of the tower; for the second, I metered the blue sky behind the tower.

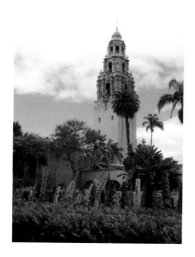

6.6 Of the two previous images, the better shot is the one with more information. In this case, the spot metering of the blue sky resulted in an image that, with slight modification in Photoshop, turned out perfectly.

(g) Push yourself and your images. Find backlit subjects, subjects in shade, subjects with a huge dynamic range. Try spot metering lots of different areas within one scene. How much do the readings vary? How do the images turn out?

5. EXPOSURE METHOD 3 – IN-CAMERA SPOT METERING

(a) Every digital camera has a built-in metering system. Your camera manual will tell you what types of metering your camera is capable of. The selections generally available are center-weighted, spot, and evaluative (also called pattern or matrix, depending on manufacturer). With spot metering, you tell the camera a specific element in the frame that you want to be correctly exposed. In some camera models, this spot can be moved around your frame with buttons easily accessible while shooting. Small boxes are illuminated within your viewfinder to indicate which area will be spot metered.

(b) Move to a new location/scene within your area. Make sure that your color balance is correct and take an incident meter reading of the main light source. Adjust your camera according to the meter reading and take a baseline shot of the area against which to gauge all other exposures.

(c) Place your gray card in the same light as the subject and take a spot meter reading of the card. Set your camera with the meter readings and take a shot. This image should be the most accurate exposure for this scene. [⬅ 6.7]

(d) Now, choose an area of your scene that is illuminated by the same light as your subject and is close to neutral gray. Remember, the gray card is middle gray, so find something that looks to be of the same tonality if at all possible. Meter this section and set the camera to properly expose the whole scene based on this new data. Take your image. How different were the readings? [⬅ 6.8]

(e) Now change the spot metering position to a few other areas. Try to find other tonalities that you think might be about the same density as middle gray. This is called substitution metering. (Two examples are green grass and blue sky.) Lots of colors could render as appropriate tonalities, so try them out to see how close they are to each other. Take good notes here so you can trace back which colors worked well when using the spot meter and which didn't.

6.7 Spot metering this scene with the gray card resulted in a perfectly exposed image.

6.8 After several experiments, this image was only off from the perfect exposure by ⅓ stop when I spot metered the low branches of the blooming tree.

6. EXPOSURE METHOD 4 – IN-CAMERA CENTER-WEIGHTED METERING

(a) Move to a new location/scene within your area. Make sure that your color balance is correct and take an incident meter reading of the main light source. Adjust your camera according to the meter reading and take a baseline shot of the area against which to gauge all other exposures.

(b) Change your camera to center-weighted metering. With this option selected, your camera will take light readings of the whole scene and create an exposure based on the data. The algorithm that the camera uses will give preferential averaging to the center of the frame, hence the name, and therefore try to appropriately expose your subject if it is centered in your frame.

(c) Center your subject and change your camera settings based on the new meter reading. Take your shot.

(d) Now, place the subject of your image off to one side of the frame and expose the image again. What changed? If you want to really see how this type of metering affects your exposure, backlight your subject by placing it in front of the sun or a bright light source. You will see vastly different meter readings between the two compositions just based on what predominantly fills the center of the frame.

7. EXPOSURE METHOD 5 – IN-CAMERA EVALUATIVE METERING

(a) Move to a new location/scene within your area. Make sure that your color balance is correct and take an incident meter reading of the main light source. Adjust your camera according to the meter reading and take a baseline shot of the area against which to gauge all other exposures. Remember, these should ultimately be shots that you are excited about taking.

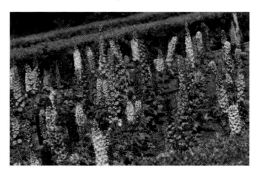

6.9 Here, I used my incident meter to get a perfect baseline shot.

(b) Of all of the in-camera metering options, evaluative is generally the best at approximating an accurate exposure for an average scene. Evaluative metering looks at the whole scene and averages the information found to create an accurate exposure for what would be an average scene.

6.10 As we would expect from a scene such as this, using the evaluative metering mode resulted in an image that is almost perfectly exposed. The overall exposure settings are ⅓ stop different from the incident meter reading.

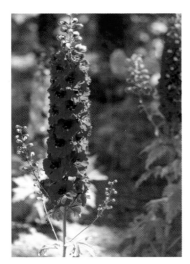
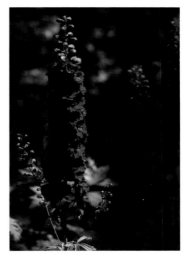

6.11 However, if your overall scene is generally dark or light, the evaluative mode can get the image very wrong. Here, the image on the left is overexposed due to the evaluative metering mode. The image on the right is the correct exposure for this dark flower and the dark foliage surrounding it.

6.12 Similarly, the evaluative mode saw this white flower as darker than it should be. The image on the left is underexposed because of the in-camera meter. The image on the right is the correct exposure for this flower and its surroundings.

(c) For this metering method, find several subjects/scenes that you would like to photograph and use evaluative metering for each of them. Try to change your lighting, your subject, and the distance between you and your subject for each image and truly evaluate which images seem correctly exposed and which ones are not quite right. If your overall scene had lots of dark tones, is your image too light? If it had overall light tones, is it muddy and dark?

8. EXPOSURE METHOD 6 – BASIC DAYLIGHT EXPOSURE

You can't always get close to your scene, and you won't always have a gray card or a handheld meter, but you can usually rely on your camera for quick adjustments—especially if you have completed and evaluated all the methods listed above. But what happens if the in-camera meter stops working?

If you do not have a functioning meter, you can still shoot daylight scenes with no problem at all. As long as the sun is lighting the scene and is 10° above the horizon, either in the morning or afternoon, you can get an accurate exposure using a rule called Basic Daylight Exposure (BDE).

(a) Move to a new location/scene within your area. Make sure that your color balance is correct and take an incident meter reading of the main light source. Adjust your camera according to the meter reading and take a baseline shot of the area against which to gauge all other exposures.

(b) For this part of the assignment, you will need a sunny day and a subject that is lit directly by the sun.

(c) Set your camera's ISO to 100, your aperture to f/16, and your shutter speed to $\frac{1}{100}$ second. This image will be perfectly exposed under those conditions, guaranteed. The reason for this is no matter where you are on the planet, the sun always has the same meter reading. The way to calculate your exposure without the help of a meter is to set your ISO where you want it, set your aperture to f/16, and set your shutter speed to 1/ISO. For our purposes, the ISO is set to 100, so the shutter speed should be $\frac{1}{100}$ sec. If our ISO were set to 400, the shutter speed would be $\frac{1}{400}$ sec, and so on. From here, you can use any exposure with equivalent settings to capture any daylight scene in the world. [⬚ 6.13]

At this point you should be able to evaluate a scene for appropriate incident or spot metering locations, gray card placement, or in-camera tonality adjustment, and use that information to determine the best method to create an exposure for any scene. You should also be able

6.13 Just setting my camera to f/16 @ ¹⁄₁₀₀ sec at ISO 100 allowed me to create a perfect exposure of this sunlit turret, with no metering or additional thought.

to determine which combination of shutter speed and aperture (and possibly ISO) will give you the image that you previsualize. Although we kept these images simple for learning purposes, the same principles apply if you are metering an indie concert in a tiny bar, a night scene on the Seine, a group of surfers at dawn, or the evening lights of Niagara Falls. Make finding the right exposure your first priority and you will be able to express yourself with composition, color, crop, subject, and moment in every image you make.

Compose Yourself

© Jesse Strigler. Courtesy of the artist.

Once you have all the knowledge about how to capture the perfect image, the real challenge starts—how do you find the perfect image? There are, of course, scenarios where the subject matter, lighting, perspective, and arrangement create once in a lifetime opportunities, and the photographer is less important than what is in front of the camera. That's not to say that images we think of as some of the most important images in history aren't well done just because of the situation, but rather that preparation for those moments is something that comes with a lot of patience, knowledge, experience, and luck. For every other image, the choices that you make as a photographer can be the difference between a mundane image and a striking, memorable, and appealing photograph.

How we capture the perfect image in large part relates to how we use our viewfinder to frame the image. Suda House, a colleague of mine, once told her class that the difference between using the LCD preview screen and the viewfinder is that when you use the LCD screen you are separate from the image and when you use the viewfinder you are using the camera as an extension of your eye. So it's really the difference between viewing and seeing. And one of the most important parts of being a photographer is learning how to see the world through the lens.

From this point forward we are going to do something that some of you might already be doing and others might find outlandish. We are going to turn off the LCD preview screen on our digital cameras. Up until now it hasn't mattered how you compose your images because we were learning how to use the equipment and learning the ins and outs of our individual camera systems. But all of the lessons from here on out are about taking the next step toward becoming an avid photographer, and that involves trusting ourselves enough to let go of the metered out, specific, controlling attention to detail, and allowing ourselves to see through the lens of our camera.

Don't fret. You might flail around a little here. That's okay. Ultimately, if it takes you a minute to review your situation, set your exposure controls, find your white balance, and start looking for your image, you may have already lost the shot. In fact, you may have lost dozens of opportunities. So far you have been taking your time with every shot, but now we need to start picking up the pace. We do this because we want to be able to photograph the great, spontaneous moments as well as the carefully controlled, calculated ones. If we require ourselves to pick up the pace when it doesn't matter, like when we are working our way through the assignments in this book, then we will be better prepared for the moment when it does matter.

You might get everything wrong here. You might forget all of our metering lessons, inadvertently change the white balance to cast a green

glow over everything, or even set the exposure off the charts and get a washed out or black image. That's great! Truly, you can learn more from your mistakes than your successes. So take to heart my request here that you work quickly and from instinct, and follow the instructions below. You have to fail your way to success. The more you learn from your mistakes now, the better you will become.

If you find that you aren't making any mistakes, take yourself to a new location that makes you slightly uncomfortable, go someplace that you have never been before, or go to a local event and try to get "the money shot." Putting additional pressures on yourself will help you truly evaluate whether or not you have absorbed all of the information from the previous exercises. If you have, excellent! Keep working, keep shooting, and keep evolving. If you haven't, don't worry; the fact that you haven't means you are finding out what you need to relearn.

When I was learning to ski as a child in the mountains of New Mexico and I would fall down, my father would swish to a stop beside me, prop me up, dust me off, look me square in the eyes, and say, "If you aren't falling down, you aren't learning." So let's learn.

In assignments 7 and 8, we are going to push ourselves to use our new knowledge and create a series of images of subjects that we like. I will provide some instructions for how to compose your scene to get more interesting, more unusual images that will add to your photography.

The best way to start pushing the visual appeal of your images is to shift the main subject away from the center of your frame and position it at one of the intersection points created when you dissect both the vertical and horizontal lengths of your frame into thirds. This is known as the Rule of Thirds, and it allows you to instantly create a more unusual and appealing image. In assignment 7 we are going to run through a series of situations in which the ultimate image is enhanced by simply shifting our camera and composing an off-center image.

© Jesse Strigler. Courtesy of the artist.

What Will You Need?

Now that you understand all of your equipment, you need to make the appropriate decisions about what equipment you want to bring along, where you want to go, and how you want to approach your image making. Of course, you can always reference previous sections and find the equipment you should be utilizing, but, for your sake, I am going to stop providing you with a list of what to bring along. At this point, you should evaluate your trip, your requirements, your subject, your mobility, and your image goals. Once you do that, you will know what to bring along with you.

What I Recommend

⊕ A carefully evaluated set of equipment for your circumstances
⊕ A notebook and pen

Purpose

The purpose of this assignment is to simultaneously help you improve the composition of your images and push you to utilize the information that we have covered in the past five assignments. Theoretically, this assignment should be much more fun, and much more nerve-racking, than the previous assignments. More fun because you have the flexibility to

photograph whatever your heart desires; more nerve-racking because I am not going to tell you what to shoot, what settings to use, or where to go. At this point, your creativity comes into play and you have to determine what you want to photograph and what you want to say with those photographs. Ultimately, trust your instincts, photograph what you love, and be true to your creativity. Then create your compositions following the procedure below.

Procedure

1. Preparation – This is the most important step toward becoming a better photographer. Turn off your LCD preview screen.

2. Set Up – Determine what you want to photograph and bring along all of the equipment you need to get the shots you want. This can honestly be anything, anywhere, and at any time of day. You can start in your comfort zone or push yourself, but either way, think about what you want your ultimate result to be.

3. Initial Camera Settings – Once you get to your desired location and have picked your subject, use your knowledge to set your camera. Trust yourself here! Try to do this without referencing notes or manuals or this book. If you try to apply your knowledge without second guessing yourself, you will discover the areas in which you need to improve. Then you can address those specific issues later. As always, keep good notes.

4. Center your first subject in your viewfinder and take a photograph.

7.1 I chose to photograph the statue at the center of this fountain in Balboa Park because the statue has a gaze—the direction of the line of sight of the statue. I also chose this subject because it won't move around like an animal or get impatient like a friend. Once you understand the Rule of Thirds, you can quickly determine which direction to go and where to place your subject, so you won't need it to stand still.

5. Now evaluate the subject for flow. If the subject is a person, where are they looking? What is the background? What is the foreground? With portraits, animals, and movement, viewers are psychologically more comfortable looking at images in which the "flow" of that subject (direction of the gaze or path of movement) is directed into the frame. Find out where the flow of your subject is going and create four images:

(a) Image 1 – Holding your camera in landscape orientation (horizontally), position your subject in the upper third of your frame, away from the flow, allowing the gaze or direction of movement to fill the remainder of the space.

7.2 The lines here indicate the intersection of the horizontal thirds and the vertical thirds for this orientation and this image. I placed the crosshairs on the subject's cheekbone to allow a little more room for the braid and shoulders, but you can place the crosshairs on any part of the subject you want. This image represents the Landscape Upper Third.

(b) Image 2 – Still holding the camera in landscape orientation, position your subject in the lower third of your frame, away from the flow.

7.3 Each time you move your subject within the frame, try to position the crosshair intersection points on the same spot on your subject for evaluation. This image represents the Landscape Lower Third.

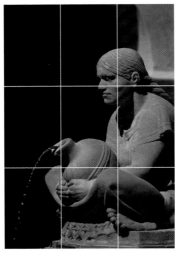

7.4 This image represents the Portrait Upper Third.

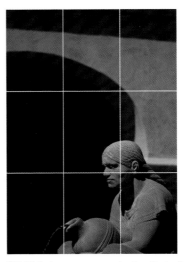

7.5 This image represents the Portrait Lower Third.

(c) Image 3 – Turn the camera 90 degrees to portrait orientation (vertical) and position the subject in the upper third of your frame, away from the flow. [⊡ 7.4]

(d) Image 4 – Still holding the camera in portrait orientation, place your subject in the lower third of your frame, away from the flow. [⊡ 7.5]

6. What you end up with are five images of the same subject, each with a very different psychological and visual appeal. Here is where your creativity comes into play. What image do you like the best? Why? What image do you like the least? Why? What types of subjects would be best demonstrated by each of the four Rule of Thirds locations? What types of subjects would be best shot in the center of the frame?

7. Now starts your expedition. Now that you can see what the slight orientation changes do for your images, your goal is to find ten completely different subjects that work best in each of these ten orientations.

Image 1 – Landscape orientation upper left third.

Image 2 – Landscape orientation lower left third.

Image 3 – Landscape orientation upper right third.

Image 4 – Landscape orientation lower right third.

Image 5 – Landscape orientation center frame.

Image 6 – Portrait orientation upper left third.

Image 7 – Portrait orientation lower left third.

Image 8 – Portrait orientation upper right third.

Image 9 – Portrait orientation lower right third.

Image 10 – Portrait orientation center frame.

8. Evaluation – Remember, the purpose here is to push your creativity with framing as well as test your photographic skills. When you evaluate all of these images, you should be looking at the technical aspects as well as the total appeal of the images. How successful do you think you were with each of the orientations? Are there some subjects you feel would be equally successful in multiple orientations? What happens if you change the orientation to go against the flow? Are the images better or worse? Why? What kind of statement are you making when you work with flow or against it?

9. Reshoot – If there were any images that you feel weren't as successful as they could have been, either because of technical or aesthetic reasons, go out and shoot that subject again! Every time you reshoot you become that much better as a photographer. Push yourself to explore what you have done wrong and find a way to fix it. If you fix it this time, your chances of making the same mistake again are greatly reduced. If you don't try to fix it now, you will likely make the same mistakes over and over. Returning to the scene of your defeat will give you control over your evolution as a photographer. Give yourself that opportunity and I guarantee you will be better for it.

Now that you have a reference for creating more interesting, dynamic images just by pulling your subject off center, be aware that you can also break that rule! Sometimes, symmetry is a subject's best friend; just be sure that you, as the conscientious photographer, have evaluated the composition of your image and determined how to best handle your subject.

While moving your subject out of the center of the frame is an excellent way to change the visual appeal of your imagery, in a lot of cases the subject itself is far too busy to make for a readable, relatable image. In 9 out of 10 instances, this is because too much of the subject is included in the frame. A general rule of thumb is to evaluate your scene, find the subject that most interests you, and then get closer! Establish your image so that the subject is readily identifiable and separated from the background by color, tonality, or depth of field. If you start to think through the lens and evaluate your perspective of the subject as well as the natural surroundings, you will be able to see how you can separate your subject from the background and create a more interesting image.

© Kevin Osborn. Courtesy of the artist.

What Will You Need?

The same rules apply here that did in the previous assignment. You are on your own to determine what equipment to bring and what settings and subjects to choose. (Don't fret, though, you can always refer back to previous sections if you get stumped.) Remember, failing is an essential step toward succeeding! So, with that in mind, I encourage you

to push yourself further and continue to get out there and shoot. At a minimum, I want you to follow the listed procedure here, but don't stop just because I have given a certain set of constraints. You can continue to get closer and closer to your subject until you are satisfied or your equipment can no longer handle the distance.

What I Recommend
- A carefully evaluated set of equipment for your circumstances
- A notebook and pen

Purpose
The purpose of this assignment is similar to that of assignment 7. Follow these guidelines to try and create a better image, and think about pushing yourself to develop a familiarity with all of your equipment's capabilities. The more familiar you are with your equipment, the quicker you will be able to react when the time is right and the scene is set for the perfect photograph. I can lead you through process, but only you can drink in the imagery.

Procedure
1. Preparation – We're going to leave our preview screen off. No cheating.

2. Set Up – Find a scene that you want to shoot. You can determine your subject as well, but look for a scene that is a little busy, rather than clean and empty. If you are shooting your subject in a white room with one window and no furniture, getting closer to it might not be the best solution. If you are shooting in an average scene—outside in a park, on a pier, downtown in a big city—you will be more challenged to find an excellent image in which the subject is not lost in the chaos of the scene.

3. Initially, I want you to follow your instincts. Set up a baseline shot, drawing upon everything we have discussed up until this point. Determine your meter reading and camera settings and then take that first shot. [⊟ 8.1]

4. Now I want you to evaluate your scene and determine the true subject. Move in closer to that subject. You can do this either by using a longer lens or by physically moving. Think about the results that you got in Section B. What lens will work the best in this situation? Would it be better to get closer physically, or are you limited by how close you can get to your subject? Take some shots to play with different distances, angles, and lenses. [⊟ 8.2–8.3]

8.1 This image is correctly exposed and white balanced for the shady side of the building, which leads to an overly warm-toned scene and an overblown sky. Although the house and, more specifically, the wonderful turquoise doors are correctly exposed, the image has trouble with focus and direction. The main subject gets lost in the busy, overwrought image.

8.2 I decided that I wanted the French doors to be the subject of the image. To try and accomplish this, I first used a longer focal length to get closer without moving from where I stood. The resulting image has a more clearly defined subject, but there are still lots of distractions.

8.3 In order to get even closer, this image was taken with an even longer lens but, again, from the same original perspective.

8.4 To get this image I thought about what I wanted the perspective of the image to be. I could no longer stand in the same spot and really get the image I was looking for. I moved closer to the door so that I could look up at it, and I used a longer lens to get in close and frame the door as the main subject. What I love here is that now you can see the lace curtains, which were lost in the previous image.

5. Now that you are closer, look around your subject to find what would make the ideal background. To determine this, evaluate how the subject is lit. This will help dictate where you need to be to get the best possible image of the subject. Next, determine what the background will be when you position yourself to get the best shot of the subject. Generally, the lighting on a subject provides some leeway for you to move yourself or the subject in such a way as to maximize the benefit of the background. Sometimes moving a foot or two to the right or left can mean the difference between a highly distracting background and the perfect background. The perfect background might be one that contrasts your subject in tonality or color, or it could be an evenly toned background that won't distract from your subject due to contrast or bright spots. [⬚ 8.4]

6. Once you are in the correct location to get the perspective you want, think about your depth of field. If the background helps the image contextually, you might want to keep the background in focus. If the background has interesting colors but the substance is distracting—such as a billboard or a busy shop window—you might want a shallow depth of field to blur the background into a meld of colors and shapes that aren't discernable in the final image. Play around with different depths of field, perspectives, orientation, and lenses, and take a few more shots.

8.5 For this image, I really wanted to focus on the curtains, so I chose a shallow depth of field to blur out the flowers in front of the door and bring the focus to the lace pattern.

7. Now, repeat steps 4–6 a minimum of three more times. At the end of this, you should be nearly on top of your subject, and you will most likely have had to move in both with a longer lens and by physically approaching your subject. With each stage, evaluate every aspect that contributes to the image. In other words, don't just get closer, but work

through the whole process of reviewing the background, the metering, the exposure, the white balance, etc. Everything that we have done up until this point should affect every shot you take. This way, you are training yourself to be aware, responsive, and knowledgeable.

8.6 Once I was closer to the door, however, I realized how lovely the flowers in front of the house were. After I got the image of the door that I wanted, I changed my focus and perspective to display the flowers.

8.7 Using the same philosophy that I did with the door, I got closer to the flowers by physically moving toward them.

8.8 The resulting image is vastly different than where we started.

8. Repeat steps 2–7 in an entirely new location. This time, try to find a location that has fewer distractions, such as the white room we mentioned earlier. There are times when getting closer to your subject is not as impactful as staying away. Try to find such a situation. (Hint: The less cluttered the original scene, the more likely you'll be able to include a larger portion of the scene along with the subject to make a visually interesting image. The uncluttered scene functions as negative space in this scenario.)

8.9 This image of the Spreckels Organ Pavilion in Balboa Park is white balanced for sunlight, seeing as how the bulk of the image is lit by direct sunlight. There are few distractions because the pavilion is empty, and there is a good sense of the size and majesty of the performance space.

8.10 Maintaining my location and changing the lens and orientation gives me a very different image. In this case, the breadth of the pavilion is diminished and the stage becomes the focus.

8.11 As I get even closer using a wider lens, the stage becomes slightly distorted and there isn't much to look at. I also need to be aware of the white balance because now the main subject and the bulk of the image are illuminated by shade, not by direct sunlight.

8.12 This image is more successful than the previous two, but it demonstrates the details of the pavilion rather than its true emphasis. That isn't to say one or the other is better; but sometimes, moving closer to your subject changes the psychological impact of the image. You should be aware of those impacts.

8.13 Moving even closer results in an abstracted view of the structure and the image becomes more about shape, line, contrast, and texture. If your goal isn't to showcase the pavilion, this can be a very impactful image.

8.14 This was taken from approximately the same distance as the previous image, but with a different focus.

8.15 An image this close to the details could demonstrate craftsmanship or a specific plaster technique, but doesn't say much about the subject as a whole.

8.16 Finally, an extremely close image can be very lovely, but doesn't necessarily give us a sense of the greater subject. Again, that isn't to say that any of these images are necessarily the best or better than another. These images simply demonstrate the variety of information that you can convey in an image depending on how close or far you are from the subject.

9. As always, take diligent notes and review your findings. What were your successes? What were your failures? The more dedicated you are, the more you will go out and try this process in new, varied locations.

Your notes should be growing and your understanding of all of your equipment should be getting more refined. You should now be a much better photographer than you were when you started due to your diligence, patience, and attention. Keep repeating these exercises whenever you want a refresher or find yourself to be creatively blocked. Just getting out there and shooting can sometimes be the best way to break out of a funk and find a path to a new body of work.

Section E
Follow the Light

© Mercury Megaloudis. Courtesy of the artist.

As photographers, it's important that we understand what it is that we really control. Our world revolves around light—how we see it, how we use it, how we manipulate it, and, ultimately, how we capture it. Photographers are, after all, "light writers." So now that we are comfortable with the technical aspects of our craft, we need to push ourselves into the creative aspects of selecting what photographs to take. We do that by following the light.

For this first assignment, we will work on finding exquisite light in various situations to create stunning images in which the light is both actor and accent. Not only do we need to find interesting lighting situations, but we need to visualize and understand what types of subjects can best be described by the light that we see. We are looking for beautiful light that emphasizes certain aspects of our subjects.

The first thing we need to understand is what different types of light there are. The two main categories of light are specular (hard-edged, direct light) and diffuse (soft-edged, ambient light). Some examples of specular light are bare bulbs, street lamps, and, of course, bright sunlight on a cloudless day. Some examples of diffuse light would be light coming through a sheer curtain over a window and overhead light on a very cloudy day (that's nature's great diffuser). So why do we care about the types of light? Well, specular light and diffuse light do very different things. Specular light creates hard, deep shadows, which help to reveal texture and blemishes, and create high-contrast scenes. Diffuse light functions to smooth texture and reveals soft forms with diminished shadows. The type of light you use can help make the statement you want to make with your photograph.

So let's get to it.

What Will You Need?

The most important element of this assignment—and, truthfully, every photograph—is the light. Of course there are going to be situations in which you can't find ideal light, such as at a sporting event or wedding, but in most circumstances, and certainly for this assignment, you will be able to search around and find beautiful light. Wherever you find the light, bring your subject along with you. If you can't move the subject, such as when you are photographing a building or natural wonder, then you need to be patient and aware. Try to determine when the natural light sources will be most ideal for the subject and come back at that time. For this assignment, you can certainly choose to be patient, or you can pick subjects that you can easily move to try and find the best lighting situation for every subject.

What I Recommend

⊕ A carefully evaluated set of equipment for your circumstances
⊕ A notebook and pen

Purpose

The purpose of this assignment is to push your senses and your skills of observation. You should also be learning the types of light that work best for certain subjects. Once you figure this out for one type of subject, you'll be surprised how easily you can apply that knowledge to other types of subjects and scenarios.

Procedure

First things first: At this stage of the game, there are fewer constraints on your image making and therefore less specific instructions about where you should go, what you should photograph, and how many images you need to make. This is up to you! Make appropriate choices based on what types of photographs you want to create. Follow these basic guidelines to get you on the right track.

PART 1 – Find Specular Light

1. Remember, specular light is hard-edged, direct light. The easiest and most plentiful source for this is the sun, so you may want to wait for a beautiful, sunny day. If, however, you are in Seattle or England and don't want to wait for that rare occasion, you can find a bare bulb, a street light, or any light source that creates a hard-edged shadow. Think of the vacation photos that you've taken with your family members squinting into the sun with raccoon eyes and dark little shadows. That's the light we're going for (though maybe not the image!).

9.1 In this image, the specular light from the sun casts a very delineated shadow off the wrought iron railing, making an interesting mimic of shape and pattern. Specular light does this much more effectively than diffuse light.

2. What types of subjects do you want to place in specular light?

 (a) People with flawless skin are perfect for any type of light, but you can create some particularly dramatic portraits with specular light. But be careful, if your subjects have blemishes or wrinkles, specular light will clarify them!

 (b) You can also utilize specular light to reveal interesting textures like tree bark or stucco, which would be difficult to see without revealing highlights and shadows. To accentuate texture, be sure to use side lighting with your specular light so that the direction of light rakes across the textured surface.

 (c) You can also use the high contrast between highlights and shadows to create abstract images of just about anything. In this case, you

would use the light and shadow more as subject than accent; the shapes, textures, and forms are really created by your use of light and cropping.

3. So now that you have figured out some sources of specular light and some subjects that you might want to photograph, go out and find the light!

4. Once you've found an interesting lighting setup, work with your subject and the light to create several scenarios in which the light and the subject interact differently. The more you work in this stage, and the more images you take, the more you will get out of the assignment.

5. Take good notes and evaluate what types of subjects work best in the specular light that you found.

© Bobby Sanchez. Courtesy of the artist.

PART 2 – Find Diffuse Light

1. Remember, diffuse light is non-directional, soft light that seems to come from multiple locations at once. This is because diffuse light is scattered either off a surface or through a diffusion material of some kind. Because the light comes from multiple directions rather than one defined source, you don't need to worry about a hard edge. Some of the most beautiful diffuse light can be found in open shade, where your subject is under a blue sky but is not lit by direct sunlight, or near a window without direct light coming through. You can also create diffuse light by putting a sheer material, such as a translucent curtain, in front of a specular light source, like direct sunlight. This scatters the light, causing a more diffuse appearance. [⬚ 9.2]

2. What types of subjects do you want to place in diffuse light?

(a) People with not so flawless skin will love you if you photograph them in this light. Window light portraits are some of the easiest and most lovely portraits you can do right in your own home. Be aware of your background and depth of field, and be sure to use a tripod. This light is lovely, but it is fairly dim, so be sure you don't introduce camera movement by trying to handhold.

9.2 In this image, the tree that the parrot is lounging under creates a wonderful diffuse light. With this light, the colors are accentuated and the texture of the feathers and face are diminished.

(b) If you want to show a soft transition on a round object, diffuse light is an excellent source. You will see a gradual transition over the surface of the object from highlight side to shadow side.

(c) You almost always need diffuse light to photograph a reflective surface. If you photograph a reflective surface under specular light, you'll end up with a pinpoint of hot light and no discernible detail. (Think of the sun reflecting off a chrome bumper into your eyes.) Diffuse light, on the other hand, is reflected off a shiny surface in many places, allowing us to see the shape of the object. Depending on the size of the light source and its distance from the object, you can reveal more or less of the object's shape with your diffuse source. If you see a pinpoint of light reflected off the surface of the object, try to determine where the light is coming from and place a diffuser—such as a white sheet—between the light and the object. If your reflective surface looks dark, try using a diffuse reflector—like a white poster board—which will reflect light at various angles back onto the shiny surface. This will lighten the object and reveal its form.

3. So now that you have figured out some sources of diffuse light and some subjects that you might want to photograph, go out and find the light!

4. Once you've found an interesting lighting setup, work with your subject and the light to create several scenarios in which the light and the subject interact differently. I highly encourage you to find a reflective

surface in this stage to try and photograph. It creates a more compli-
cated situation, but, again, the more you work in this stage, and the
more images you take, the more you will get out of the assignment.

5. Take good notes and evaluate what types of subjects work best in the
diffuse light that you found.

PART 3 – Find Other Light

1. Like so many other elements of life, there are not merely two conditions
that apply. Things are not black or white, good or evil, or specular or
diffuse. If specular and diffuse are the extremes of the scale, you can
find a variety of wonderful lighting situations along the spectrum in
between.

For this part of the assignment, try to find each of the following
scenarios and capture the light on a subject of your choice.

(a) Dappled Light – Sometimes specular light shines through a non-
translucent subject that scatters some of the light but doesn't
manipulate all of the light. For example, think of light coming
through the leaves of a tree. Placement of your subject will be
very important here. Think about the most important part of your
subject and place it in an
area that is most directly
lit. [⤶ 9.3]

(b) Specular Light with
Diffuse Fill—If your sub-
ject is lit by sunlight and
is standing next to a large
white building, you're
going to notice that the
shadows are not as deep
and dark, and some of the
harshness of the specular
light has been dimin-
ished. This is because
the white building acts
as a diffuse fill light on
your subject. In this case,
you get the best of both
worlds—a specular look
with the power of diffuse
light coming into the
shadow side. [⤶ 9.4]

© Chuck Place, Brooks Institute. Courtesy of the artist.

9.3 In this image, the dappled light coming through a nearby tree creates a spot-light effect on the small flower and the bee, and a dramatically dark background and foreground. When luck is with you, and dappled light used well, you can greatly emphasize your subject.

9.4 In this image, the main light on the subject is still the sun, but due to a conveniently placed white wall, the shadow side is filled with a more subtle light. The hard edges of the specular light are still visible, but the shadows aren't as dark and there is texture and shape in the slight variations found with diffuse light.

(c) Translucent Light – What happens when the main light source is coming through your subject? In this case, the best method to ensure accurate tonalities across the whole image is to use a spot meter on the area that you want to be correctly exposed. Translucent light can be beautiful, demonstrating the internal lines and shapes of an object.

9.5 The light coming through the back of this leaf highlights the veins and structure of the leaf in a unique way. To achieve this look, use your spot meter to accurately expose the green of the leaf and it will automatically account for the glow of the light coming through.

(d) Backlit by the sun – Take an image of someone backlit by the sun with the camera pointed into the sun. Meter your subject's face and take the appropriate picture. Notice what happens to the contrast of the scene, the shadows on the subject, and the overall appeal of the image.

© Bobby Sanchez. Courtesy of the artist.

9.6 This image has specular, diffuse, and translucent light working to create a vibrant, summery feel. I determined that the main leaf was my subject, and exposed the image for a sunlight white balance with an incident meter reading pointed at the sun. I could have chosen multiple variations for this image, but I like the final outcome.

(e) Multiple types of light – Dappled light is technically made up of two types of light that work together to create a specific look in a scene; but this isn't the only scenario in which you might find multiple types of light interacting. Whenever you find yourself in a situation with multiple light sources, try to determine what your main subject is and what type of white balance and exposure would be appropriate for the area, and then let the other lighting elements play into the ultimate feel of the image. [⬚ 9.6]

(f) What other light situations can you think of? Go out there and try to capture them!

2. As always, take excellent notes about how you accomplished each image and what sort of results you got. You may love some and hate some, though I imagine you will be somewhere in between. After all, there are more than just the two conditions, remember?

At this point you have taken a variety of images where you were seeking out the light. When you are creating images in the future, you will strike a balance between finding the right light and capturing your subject, but this exercise allowed you to switch your brain from subject-oriented photography to lighting-oriented photography, even if it was just for a little while. Now that you have done this assignment, the possibilities

will jump out at you when you approach a new subject and you won't be stuck with one perspective, one lighting situation, or one type of image. You have the freedom to expand! So make certain that you do.

As we have discussed before, there are a number of situations in every day life where the in-camera metering systems will work perfectly well. In fact, most situations will read correctly with an in-camera meter so long as it is used properly. Yet there are many photographic situations where an in-camera meter will not only lie to you, but also possibly render your final image unusable. Two of the most extreme conditions that you can encounter are images that are primarily white, called high key, or primarily black, called low key. In each of these situations, the in-camera meter will misread the light of the situation by two stops and will provide you with either a vastly underexposed or overexposed image.

Out of the Undergloom © Robert Bradshaw. Courtesy of the artist.

What Will You Need?

For this assignment your creativity truly comes into play because we are no longer simply photographing what interests us, but rather finding or creating a scene that will help to demonstrate the principles explored here. For a high key scene we aren't looking for simply a white building or a white curtain; we want to build layers of white tones on top of one another to create a large variety of whites within the scene. So instead of just a white building, we want a building surrounded by a white fence with a white car parked in front. Instead of a white curtain, we want the curtain to be behind a white table holding a white vase with a white flower.

Beyond just a layered collection of white, however, it is important that each image contain one element of the opposite color range. So in

the image with the white curtain, the dark stem or dark center of the flower would make the image complete. We should also have a variety of textures, finishes, shapes, and subjects. In our final image, we want to be able to see each element clearly. The image won't simply be a white piece of paper; it will be a striking composition full of minute differences among the whites that define edges, shadows, reflections, and detail, with one crucial, and correctly exposed, element of black. Without the proper equipment and knowledge, capturing white with detail on the image sensor and being able to reproduce that image in print is a very difficult task. But at this point, you have all the knowledge you need to get a perfectly precise image.

What I Recommend

- A carefully evaluated set of equipment for your circumstances
- A high key scene
- A low key scene
- A notebook and pen

Purpose

The purpose of this assignment is to push your knowledge of exposure and allow you some creative freedom to test these theories and create imagery of your own. You will also be able to see just how far off exposure can be when you use the in-camera meter for such a scene. I'll give you some hints and tips for exposing these scenes properly when you don't have the opportunity to use an incident meter.

Procedure

PART 1 – The High Key Image

1. Set Up – Create your high key scene with varied whites (or light-toned colors), textures, and layers. Be sure that there is one small detail, preferably part of your main subject, that has some black in it. Without this element, this assignment won't be as useful.

2. Initial Camera Settings – It is very important in a situation like this that the white balance is determined based on the lighting. You might see in your final image that each of your whites is not a true white—some are more yellow, some more blue, etc. That's to be expected based on paint colors, dye lots, and natural anomalies. But make sure that you start at an accurate place by using your WhiBal card to set the color balance for the scene.

© Dan O'Day. Courtesy of the artist.

3. Choose something within your scene to be the subject, and then use your incident meter to meter in front of that item.

4. Set the meter readings into your camera and be sure that your custom white balance is selected.

5. Set your camera on your tripod, frame your chosen composition, and take the shot.

6. Now repeat the same shot, but this time use your in-camera metering system. Remember, the goal here is to see how varied these exposures are, so be sure that your in-camera meter thinks that the exposure is perfect before you take your next shot. Try to use the same aperture setting, if at all possible, so that you will be comparing identical images at the end of the assignment.

7. Repeat step 6 using each of your in-camera metering settings. [⊟ 10.1]

8. Download your images onto your computer and evaluate them side by side in your photo management software.

10.1 Using Adobe Bridge to view my images, I can see just how much variety I get using the various metering methods. When I use just the in-camera averaging meter, the image is rendered a near middle gray, which we would expect. With center-weighted, the image is still too dark, though better because it shows her skin tone a little. Spot metering is the most successful in-camera method, though I have to be sure to meter her skin tone rather than her dress or the background. Incident metering will always allow you to capture the best image in a scenario like this.

10.2 In this image, the main subject has light skin, is wearing an ivory dress, and is standing in front of a light beige satin backdrop. To accurately expose her, I can't rely on the in-camera meter. As seen in the Adobe Bridge screen capture, because the basic scene is white, the in-camera meter would underexpose this image by nearly two stops.

9. Are the exposure readings for each of the in-camera meter settings the same or different? Why do you think that is? Does each image have appropriate highlight detail, shadow detail, and a clean, white look, or is the image muddy and gray? [⬚ 10.2]

10. Now, try to go out and find a high key image in the world. How can you accurately determine exposure?

10.3 Though this image still has some darker tonalities, the overall exposure is a little bit too light for the in-camera meter. To get this shot, I had to get high enough to accurately meter the light that was hitting the tents with an incident meter; though I could have also metered the white and adjusted by two stops to give the image more light than the meter suggested.

PART 2 – The Low Key Image

1. You are going to follow pretty much the same procedure as before, only this time the scene should have all black tones. This image should be black on black on black, with different textures, details, layers, finishes, and levels. Make sure you include one element of white, preferably in the main subject.

2. Custom white balance your camera based on the new scene.

3. Use an incident meter to measure the light falling on your scene.

4. Set the meter readings into your camera and make sure that your custom white balance is selected.

5. Set your camera on your tripod, frame your chosen composition, and take the shot.

6. Now repeat the same shot, but this time use your in-camera metering system. Remember, the goal here is to

© Bobby Sanchez. Courtesy of the artist.

see how varied these exposures are, so be sure that your in-camera meter thinks that the exposure is perfect before you take your next shot. Try to use the same aperture setting, if at all possible, so that you will be comparing identical images at the end of the assignment.

7. Repeat step 6 using each of your in-camera metering settings.

10.4 Even though the overall image here is dark, there are still some important highlight tones. When in-camera metering is used to try and capture this image, the image is overexposed by nearly two stops. It is difficult to get an accurate meter reading of the highlight areas we want to be correctly exposed—the highlights on the models' legs and faces—even when using the spot meter. Again, the incident meter reading is the best by far.

10.5 Using an incident meter is the only way to ensure that the black dresses, the slight illumination on the models' faces, and the highlights on their skin are all appropriately rendered in the final image. If this image isn't metered correctly, the final impact will be lost.

8. Download your images onto your computer and evaluate them side by side in your photo management software.

9. Are the exposure readings for each of the in-camera meter settings the same or different? Why do you think that is? Does each image have appropriate highlight detail, shadow detail, and a dark and moody, but discernable scene, or is the scene too bright and gray? [⬚ 10.5]

10. Again, try to go out and find an image like this out in the world, and see if, with all of your knowledge to this point, you can accurately capture the scene.

In both the high key and low key sets of images, you should notice that the images made using the incident meter reading are by far superior in capture, appropriate dynamic range, detail at both ends of the spectrum, and overall feel. For the high key scene, you should be able to see details in all of the whites without any clipping or areas of overexposure that are rendered as pure white with no detail. You should also be able to see shadow detail in the black portion of the image. The opposite will be true with the low key image.

Special note: You can't always have access to the appropriate metering system, and I don't expect you to always carry around an incident meter on the off chance that you are going to run into a high key or a low key situation. So here is a trick of the trade that you should be able to verify with your own data. For a high key scene, an in-camera meter will generally underexpose by 2 stops. You can account for this by adding 2 stops worth of light to your meter reading before snapping the image. For low key images, the in-camera meter overexposes by two stops. You can compensate for this by reducing your meter reading by 2 stops worth of light.

Your photo management software should keep track of the exposure information for your image, so you can easily evaluate the number of stops between the correctly exposed image and the in-camera metered images. To do this, look at the f-stop and shutter speed listed for your two images. If you were able to keep your apertures (f-stops) the same for each image, you can easily tell how far apart the exposures are in stops. The full stop shutter speeds, in seconds, are 1, ½, ¼, ⅛, ¹/₁₅, ¹/₃₀, ¹/₆₀, ¹/₁₂₅, ¹/₂₅₀, ¹/₅₀₀, ¹/₁₀₀₀, ¹/₂₀₀₀. Let's say that your correct exposure was f/8 @ ¹/₂₅₀. If your image was underexposed by two stops, it would read f/8 @ ¹/₁₀₀₀. If your image was overexposed by two stops, it would read f/8 @ ¹/₆₀.

The same logic applies to varied f-stops, so if you did change your f-stops, you can determine the difference in stops in the same way. The full stop increments for f-stops are 1, 1.4, 2, 2.8, 4, 5.6, 8, 11, 16, 22, and 32. So, again, if your correct exposure was f/8 @ ¹/₂₅₀, your underexposed

image would be f/16 @ ¹⁄₂₅₀, and your overexposed image would be f/4 @ ¹⁄₂₅₀.

Don't worry if the f-stops you used aren't listed here. Every camera adds additional precision to exposure with ½ or ⅓ stop increments between the full stops for both f-stops and shutter speeds. If your numbers are different than these, just find the closest f-number and approximate the stop differences between your exposures. For instance, f/5 is ⅔ stop higher than f/4 and ⅓ stop lower than f/5.6. So if your exposure went from f/5 to f/11, there is a difference of 2 ⅓ stops.

You can use your camera as an additional aid in determining actual data. Click through the settings to see if you have a ⅓ stop or ½ stop camera, and then just count the increments between the correct reading and the incorrect reading. (To determine if you have a ⅓ stop or ½ stop camera, set the aperture to f/4 and close down to f/5.6. If there is one resting point in between, you have a ½ stop camera. If there are two resting points, you have a ⅓ stop camera.)

Touchdown

You've done it. You've pressed through the obstacles and circumvented the problems and ended up in the end zone. At this point you should have completed all ten assignments at least once, possibly many times over. You should know the controls of your camera, the capabilities of your lenses, the successes and failures of your presets, and how to work with each of these things to get better pictures. Your eye should be trained to see more interesting perspectives and compositions. You should understand how to look for light, and how to balance the exposure and color of the scene to fit your ultimate vision.

You should be in control.

And that is the goal of this book: to give you the skills that allow you to work within your circumstances and with your personal equipment to seize every moment and create art. You are no longer taking snapshots; every element of your image should be considered before you click the shutter-release button, even if that consideration takes a fraction of a second.

If you don't feel you are up to par yet, don't worry. It can take time to become comfortable with a knowledge base of this level. Keep trying. Keep shooting. Keep seeing the world through your eyes and you will be surprised at the results.

The best thing that you can do now is not stop, ever. Take hold of the photography in your life and make it mean something to you and to future generations. Photography is still our greatest recorder of cultures, trends, families, and ourselves. It is our responsibility to continue to take images to document what is happening now so that when the world looks back, they have something to see. So why not make those images stunning, breathtaking, impactful statements?

Well, now they can be.

Congratulations, photographer.

Index